GRIT, GUTS AND GLORY

PORTRAIT
OF THE
WEST

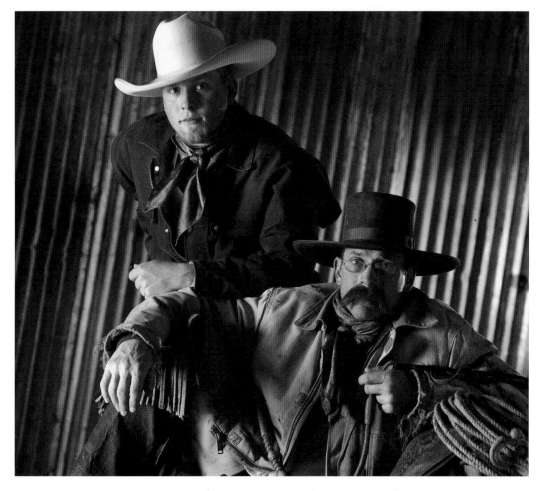

THE LIVES, WORK AND PLEASURES
OF COWBOYS & SHEEPHERDERS

COMPILED AND EDITED BY
C. J. HADLEY

PUBLISHED BY PURPLE COYOTE CORP.
& RANGE MAGAZINE

*ON THE COVER: Doug Groves with son Grant, T Lazy S Ranch, Battle Mountain, Nevada.
Doug has worked as a buckaroo for more than twenty years. He is cow boss at the TS and a world-class rawhide braider.
His reins are braided; the coiled rawhide reata is twisted. The hides once wore the T Lazy S brand. © Jeff Ross*

Now and then, when the days grow short, the darkness catches up with you
out on some lonely trail that runs on a long stretch into nowhere.
The sky is a smooth dome of canvas spread with an unbelievable palette of color.
Out here, it seems like a spectacular private show meant for a small audience.

Publication of this book was made possible by generous donations from people who care about the American West.

EDITOR: C. J. Hadley

WRITERS: Tim Findley, Barbara Wies

DESIGNER: John Bardwell

Library of Congress Cataloging-in-Publication Data
Hadley, C.J.
Grit, Guts and Glory: Portrait of the West
Caroline Joy Hadley
ISBN 0-9744563-2-2
LCCN-2004095646
Published at $39.95 per copy by Purple Coyote Corp.,
Carson City, Nevada, U.S.A.

COVER PHOTO: Doug Groves, cow boss of the T Lazy S Ranch in Battle Mountain, Nevada, with son Grant. © Jeff Ross

PHOTO THIS PAGE: Under the famous West of the Pecos sky, Chris Lacy points out each cowboy's territory for the day's gather, 06 Ranch, West Texas. © Barney Nelson

Printed in Hong Kong.

FOREWORD

GRIT, GUTS AND GLORY. BY C.J. HADLEY

Beautiful. Empty. Healthy. Productive. Wild. Free. This is the American West. It is home to cowboys, sheepherders, predators, prey, users and producers.

It is not an easy place. Nature can be cruel. Precipitation on western ranges varies from a few dozen inches to less than three in a year. Drought, flood, disease, pestilence and, more often lately, fire stalk the land.

Some parts of the West are so dry water escapes only by evaporation. Fires have burned so hot in unmanaged, overgrown forests that enormous swaths of land now lay barren.

In the past few decades, badly written laws meant to help endangered species and wildlands have changed the centuries-old rules. Ranchers are being pushed from the land. Even though everyone agrees on the need for clean air, clean water, healthy lands and abundant wildlife, scientists are discovering that the vast spaces of the American West are more productive and diverse with managed grazing animals.

Recognition comes slowly. As long as livestock and their caretakers are out there, the cowboy traditions and communities will struggle on and survive.

Some say the West is bleak. Innocents race down asphalt highways seeing only mirages, dust devils and rolling tumbleweed. In the open spaces, far from the road, season by season, ranchers can sense the presence of God. They are inspired by the wildlife, creeks and canyons; gullies, grass and willows; wild meadows, flowers and creeks.

It is lonely out here. But for cowboys and sheepherders and their families who endure the pain and divinity of nature, for the ones with grit and guts, for the ones who are lucky enough, it's a place where dreams become real and faith, love, labor and hope become glory.

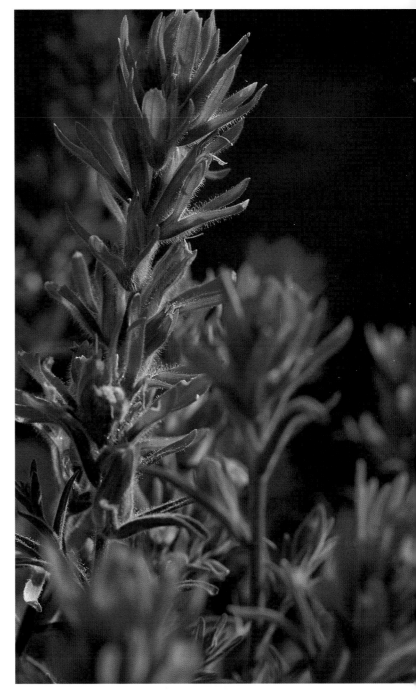

Indian paintbrush, common in mountain meadows, thickets and forest openings throughout the West.
© Linda Dufurrena

CONTENTS

4

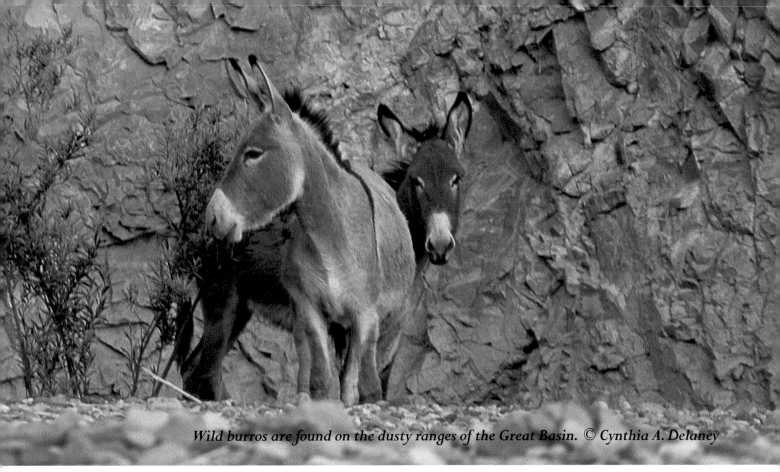

Wild burros are found on the dusty ranges of the Great Basin. © *Cynthia A. Delaney*

Buck in velvet enjoys rancher's hay field in eastern Oregon.
Where ranches flourish, wildlife thrive. © Cynthia A. Delaney

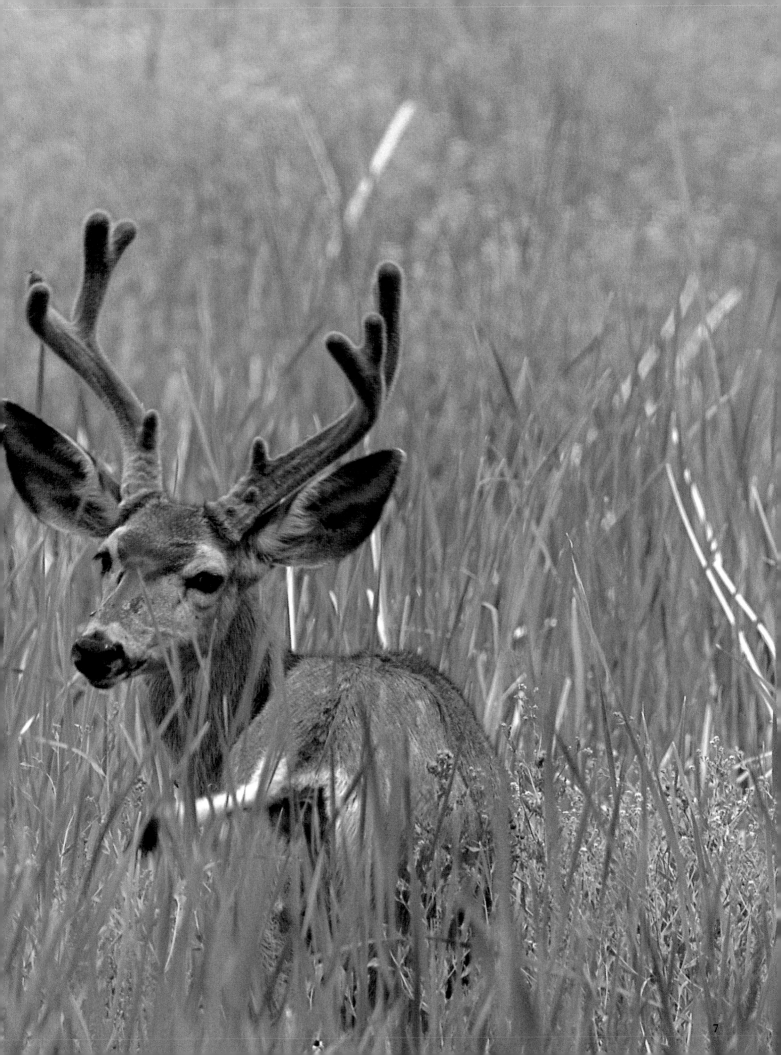

WHERE THE PAVEMENT ENDS

"Just past where you cross the creek again, you look up left and you'll see that road going through the aspen. It's got some rocks and ruts, but you'll be okay." They never expect you to come in anything foolhardy, less than a pickup, and most folks who live really out in the country suppose you must be as good as they are at keeping three out of four wheels on the ground most of the time. That's all it takes, really. That and a little patience. Just getting there is part of what tells you it must be worthwhile.

They say that was the reason why President Ronald Reagan offered his own Chevy Blazer to bring Queen Elizabeth II up the creek-bed road to his Santa Barbara ranch in the 1970s. She was said to be amazed at the view and at the hot dogs served for lunch, and then she ordered a Royal Air Force helicopter to take her back to her waiting yacht.

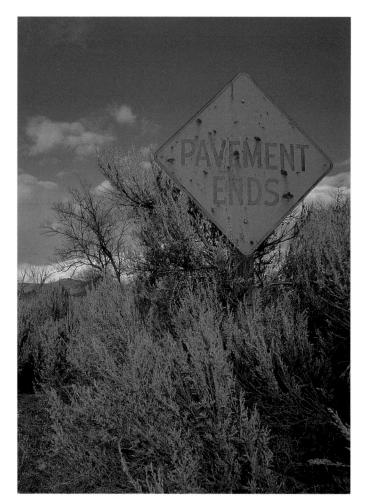

Continue at your own risk where the blacktop ends and the sagebrush begins, Golconda, Nevada.
© *Larry Angier*

Road to the windmill that pumps water for the stock tanks, San Rafael Valley, Arizona, close to the Mexican border.
© *Larry Angier*

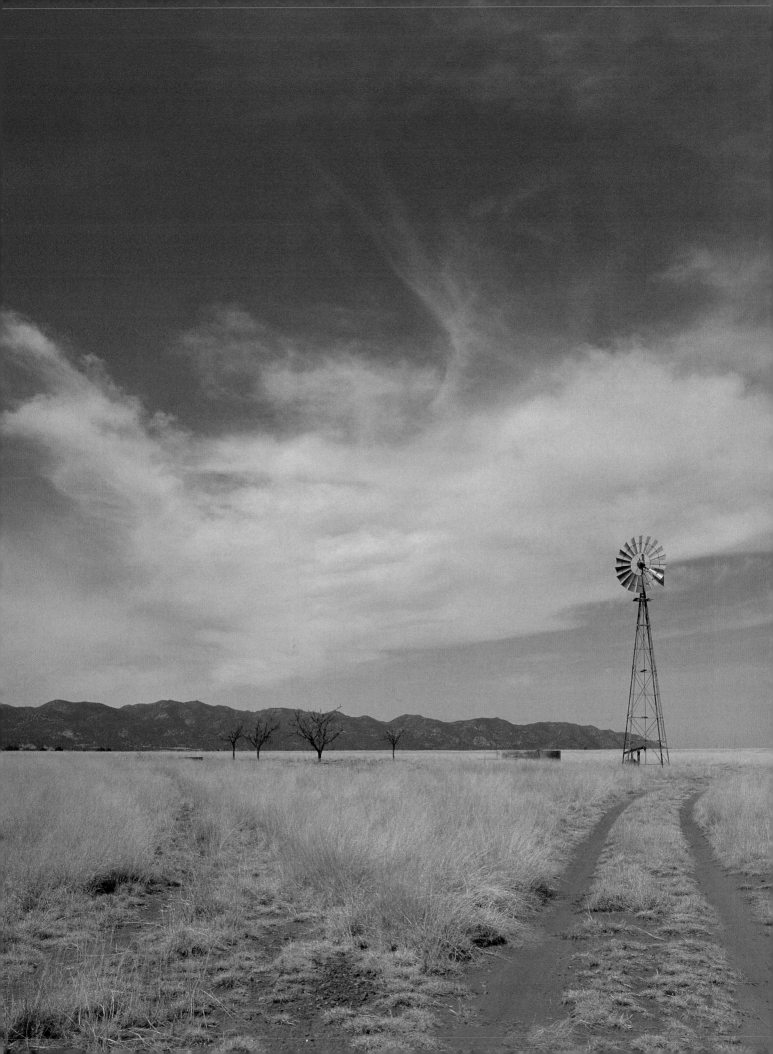

Nowhere else in the United States has been more studied, analyzed, planned and re-planned than the seventeen states west of the Mississippi. Maybe no other place in the world has been portrayed as so abused and yet so attractive. Nearly all of America's children born in the last two centuries must have held, however briefly, that dream in their hearts or their minds of owning a piece of the West. For virtually all our cultural memory it has resided as legend and heritage, somehow available to us all. Yet few, even in the West itself, can today claim to own much more than a patch of lawn. Most of the rest is still wild, still among the least populated of all places on the continent.

There are ghost towns there that tell of failed ambitions and dreams. There are riches yet to be discovered. But most important, there are still too few people to make a political difference. A periodic shortage of water has always cursed some regions. A strangulation of transportation has halted the growth of others. But the West has always suffered most from its shortage of votes.

Time after time, it would require extraordinary effort by extraordinary people just to win enough influence to survive. They call it "grit."

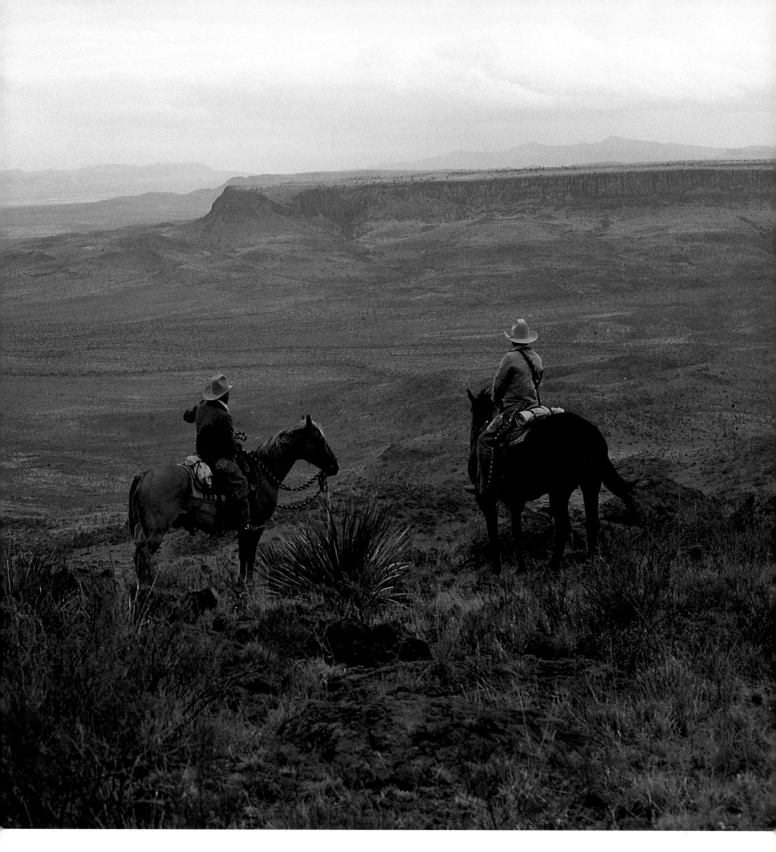

Private land ranchers in Texas have kept many thousands of acres of scenic country unfenced and in pristine condition in West Texas. It's a challenge for new cowboys to learn this big country. Here Mike Capron and Joel Nelson look for landmarks.
© *Barney Nelson*

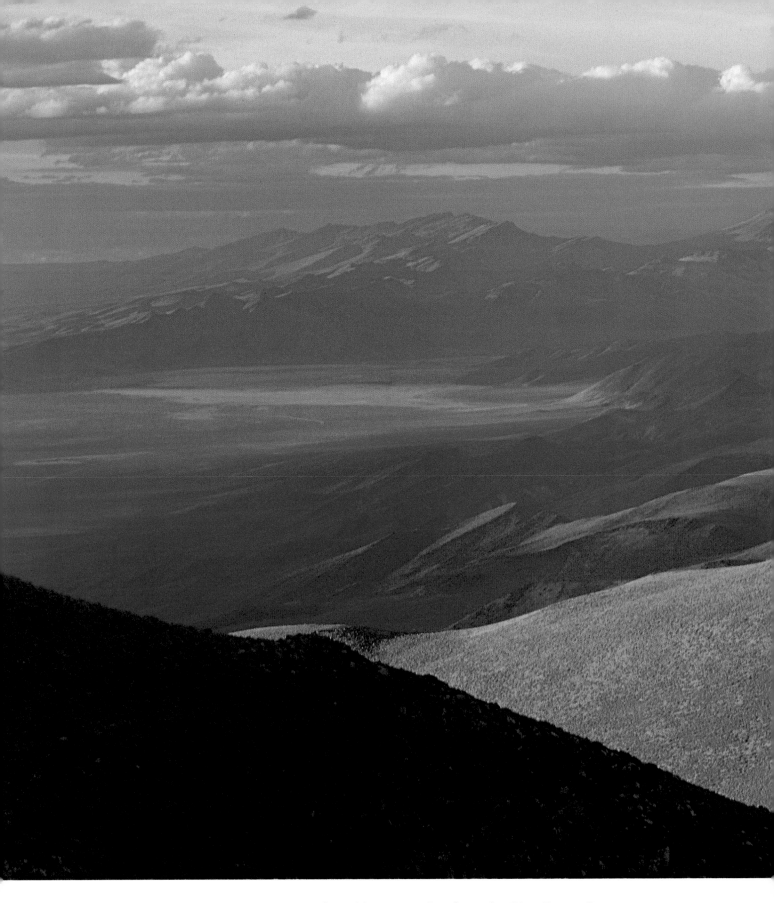

View of Pueblo Mountains from the Pine Forest Range
in northern Nevada looking toward Oregon.
© *Linda Dufurrena*

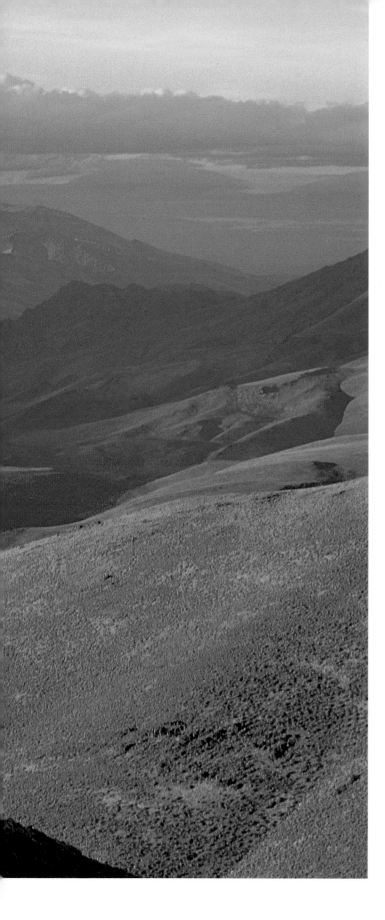

Wild iris, Nevada.
© Linda Dufurrena

A water trough for cattle at DeLong Hot Springs on the road to Sulphur, Nevada at the southern end of the Jackson Mountains. Wildlife and mustangs love to share this water hole.
© *Linda Dufurrena*

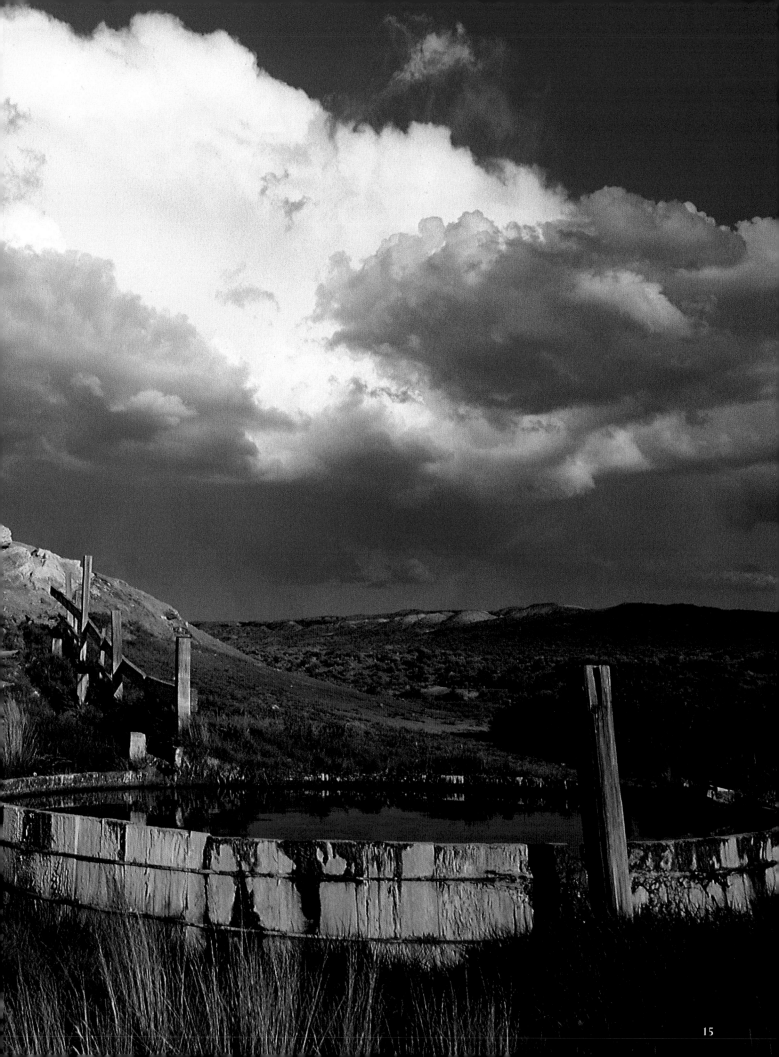

The Ecology of Ranching

By Richard L. Knight, Ph.D.

Listen to this: "Livestock grazing has profound ecological costs, causing a loss of biodiversity, disruption of ecosystem function, and irreversible changes in ecosystem structure."

Now this: "The trend of U.S. public rangelands has been upwards over a number of decades and the land is in the best ecological condition of this century [the twentieth]."

Could both be right, or wrong?

The future of western ranching and the role of science in shaping public policy regarding ranching is still very much a topic under discussion. What gives added urgency to this issue is the rapid conversion of ranchland to rural housing developments in much of the West.

As ranches fold and reappear as ranchettes, twenty miles from town and covering hillsides, people of the West and beyond increasingly wonder what this New West will resemble. For with the end of ranching and the beginning of rural sprawl comes the question most central to conservationists: "Can we support our region's natural heritage on a landscape, half public and half private, but where the private land is fractured, settled, and developed?"

Some people think it is a far stretch to connect livestock grazing with former-city-people-now-living-country, but I see it differently. Ranching and exurban development are part of a single spectrum of land use in the West, representing the principal alternative uses of rangelands in much of the mountainous New West. This is so because the protection of open space, wildlife habitat, and the aesthetics of rural areas runs right through

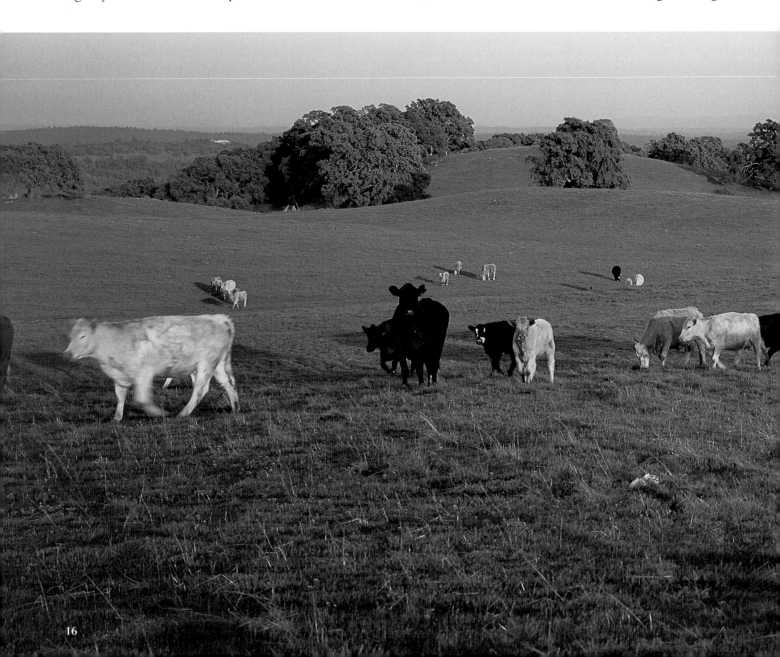

agriculture. At one end stands a rancher; at the other a developer.

As we transform the West, seemingly overnight, we see the region's private lands reincarnated as chopped-up, ubiquitous estates ranging from mobile homes to mansions that are covering hillsides faster than Herefords can exit. We have arrived at a point in western history where conversations about western lands and land health, grazing and ranchettes are entwined, and cannot be separated. They must be dealt with simultaneously when discussing the future of our Next West. The science needs to be accurate, not value driven, and the conversations about cultural and natural histories need to be honest, not mythologized.

Science is important in these discussions, but to be useful, the science must be done carefully so that the answers are the best we can get. Ranchers and scientists and environmentalists need to look better and listen

Cactus, Yerington, Nevada. © *Linda Dufurrena*

Cattle graze the spring grass at the base of the Sierra foothills, thirty minutes from the state capital in Sacramento, California. © *Larry Angier*

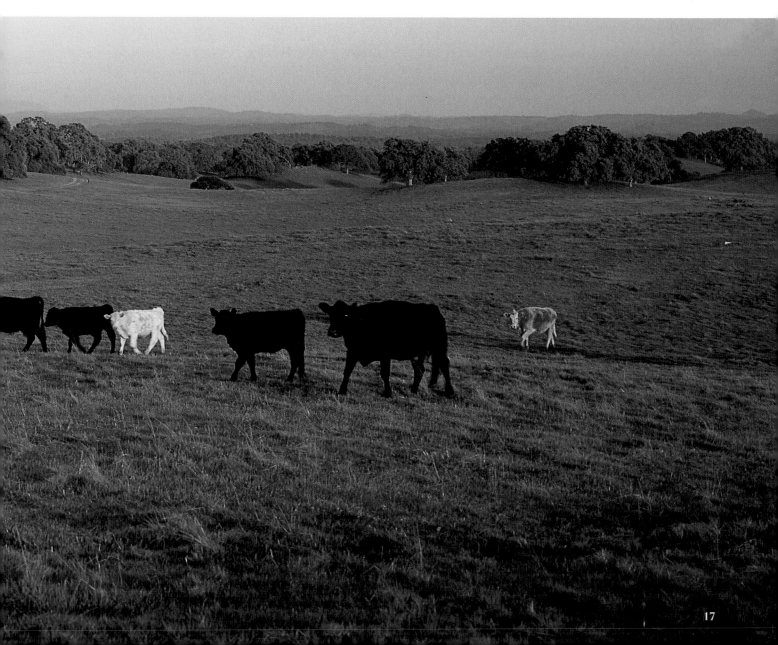

more carefully.

A Wyoming rancher recently stood before an audience of non-ranchers and apologized for what his parents, grandparents, and great-grandparents did to the land. He said, approximately, "I am sorry for what my ancestors did to this land; they abused it, they were hard on it during dry years, and they kept too many animals on it for too long during lows in the beef business. I know that they taught me much about the land; they also spoke of what they had to do to make a living during the hard times. I cannot change how my relations lived on the land before I came but I can work hard to make the land better for my children. If what you want is an apology from me when I was just a gleam in my Daddy's eye, I apologize. Now can we move on?"

There are obvious implications to this story but, for the present, we might think hard about what he asked. In forgiving him the destructive land management practices, albeit unintentional, of his forebearers, perhaps we can acknowledge our own limited understanding of what constitutes good land management practices, even today.

Perhaps we can appreciate that our knowledge of

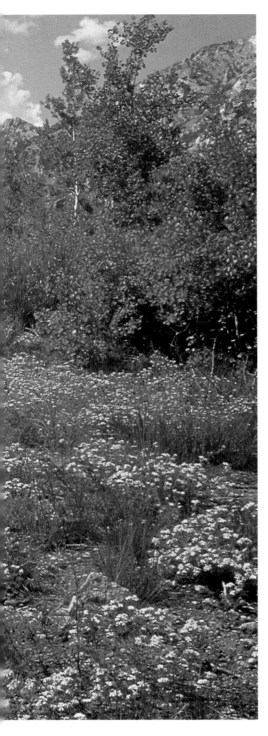

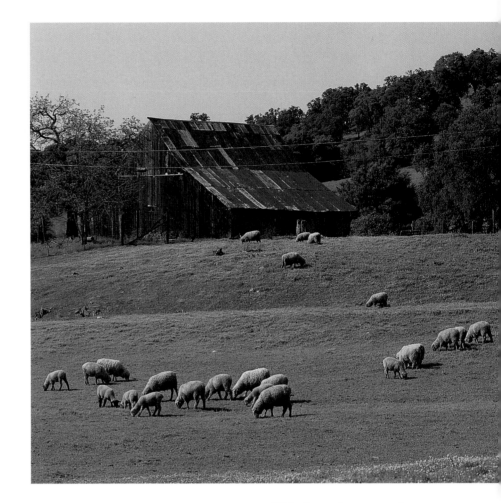

*Old-time sheep ranch near
Angels Camp, California.*
© *Larry Angier*

*Ruby Mountains with
wildflowers, northeastern Nevada.*
© *Cynthia A. Delaney*

good grazing practices is evolving and that we are learning, adaptively, as we continue to better understand the interplay of wind, soil, plants, water and drought that make up the principal plant communities of the arid West, its grass and shrublands. If we are able to understand and move beyond the incontestable fact that we harmed western lands in the past, perhaps we can refocus our energies toward working together to put right what was once torn asunder.

Northern Larimer County, Colorado, where I live, is a blend of protected areas, ranches, and ranchettes. Jeremy Maestas, Wendell Gilgert and I examined the bird, carnivore, and plant communities across these three different land uses. If ranchettes indeed attract generalist species and repulse species of conservation concern, then we hypothesized that biodiversity would be more similar on protected areas and ranches than on ranchettes. And that is what we found.

Weedy species, such as magpies and cowbirds, showed elevated populations across the ranchette land-use category while species subject to conservation concern, like towhees and grassland sparrows, were

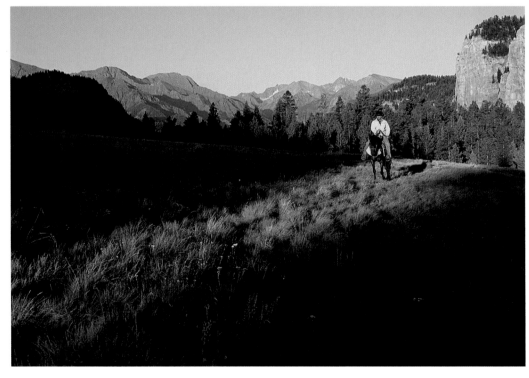

Rainbow over Sacramento County grazing field in Northern California cow country.
© *Larry Angier*

Wrangler Ryan Selk checking for bear, 7D Ranch, Sunlight Basin, Cody, Wyoming.
© *Mary Steinbacher*

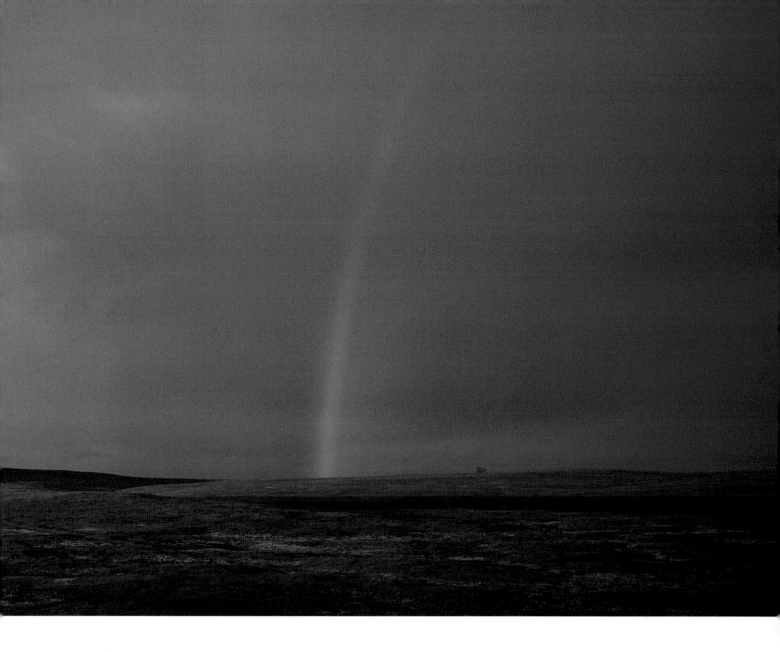

common only on protected areas and private ranch lands. Importantly, the protected areas and ranchettes—unlike the ranch lands—supported the highest number of invasive plant species. That is, ranchers were promoting native grasses while the ranchettes and protected areas had the least well-stewarded rangelands. Likewise for carnivores. Ranchettes were dominated by dogs and cats, while ranch lands had the highest densities of coyotes and bobcats.

The upshot of the biological changes associated with the conversion of ranch lands to ranchettes will be an altered natural heritage.

In the years to come, as the West gradually transforms itself from rural ranches with low human densities to increasingly sprawl-riddled landscapes with more people, more dogs and cats, more cars and fences, more night-lights perforating the once-black night sky, the rich natural diversity that once characterized the rural West will be altered forever.

We will have more generalist species—species that thrive in association with humans, and fewer specialist species—those whose evolutionary histories failed to prepare them for elevated human densities and our advanced technology. Rather than lark buntings and bob-cats, we will have starlings and striped skunks. Rather than rattlesnakes and warblers, we will have garter snakes and robins. Is that the West we want? It will be the West we get if we do not slow down and get to know the human and natural histories of our region better, and then act to conserve them.

If what I have presented here is true, that ranch lands are compatible with our region's natural heritage and that herbivory is a necessary ecological process in the restoration and maintenance of healthy rangelands, then why are ranchers and livestock grazing so vilified? Why have scores of environmental groups banded together for "a prompt end to public lands grazing"?

Could it be because of different values? I began this

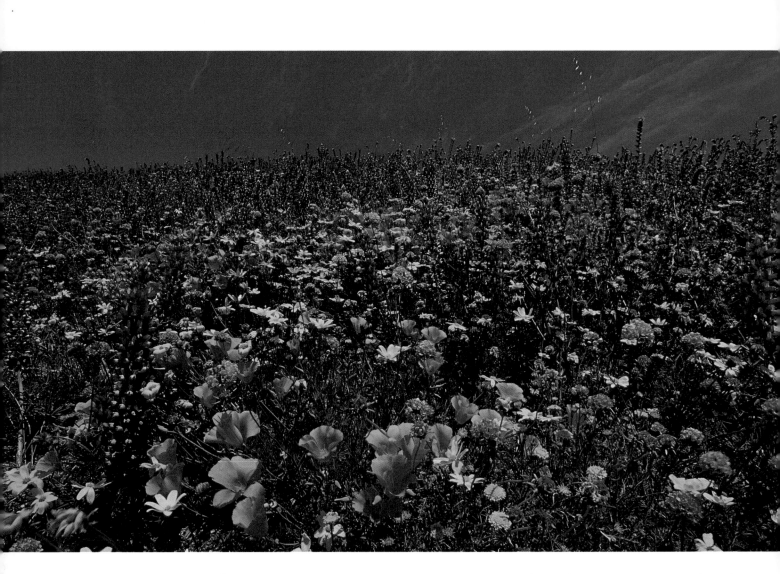

Field explodes with wildflowers on ranch land that has been grazed for years near Gorman, California. © Larry Angier

Morning mist over Bog Hot Springs in the Pine Forest Range, west of Denio, Nevada. © Larry Angier

essay reporting how a conservation biologist wrote a review of livestock grazing that universally condemned it as a land use incompatible with biodiversity. In trying to understand how his review differed from what other scientists have reported, ranging from the National Academy of Sciences to noted plant ecologists, I questioned, was it just a difference in values? Might some westerners want the public and private lands free of manure, cows, sheep, and fences because they want them for their own uses, such as mountain biking and river rafting? Do some want ranchers and their livestock off the western ranges because they believe what others have told them, that cows and sheep sandblast land and that cattle barons are arrogant bastards, intolerant of any but their own kind?

My own sense is that differing values and distorted mythology can obscure facts, and that at the end of the day, emotion may trump judgment. Would it make any

difference if we found that ranchers are stewards of the land, that cows are being used as a tool in the recovery of arid ecosystems, that open space, biodiversity, and county coffers are enriched more from ranching than from the rapidly eclipsing alternative, ranchettes?

Perhaps it all comes down to values—of the rancher, the urban environmentalist, the scientist and the government employee. Each of us is in love with the West, its punctuated geography, its rich cultures, its wildlife, and its heartrending beauty that stretches sometimes further than our imaginings. Ranchers will have to change; they will have to change more than any of us. They can do that; one only needs to look at their history. They have changed in the past, they have adapted, and now they are evolving to fit a land on which demographics, economies, and yes, even environment is different from what it had been. But we should change as well. Other

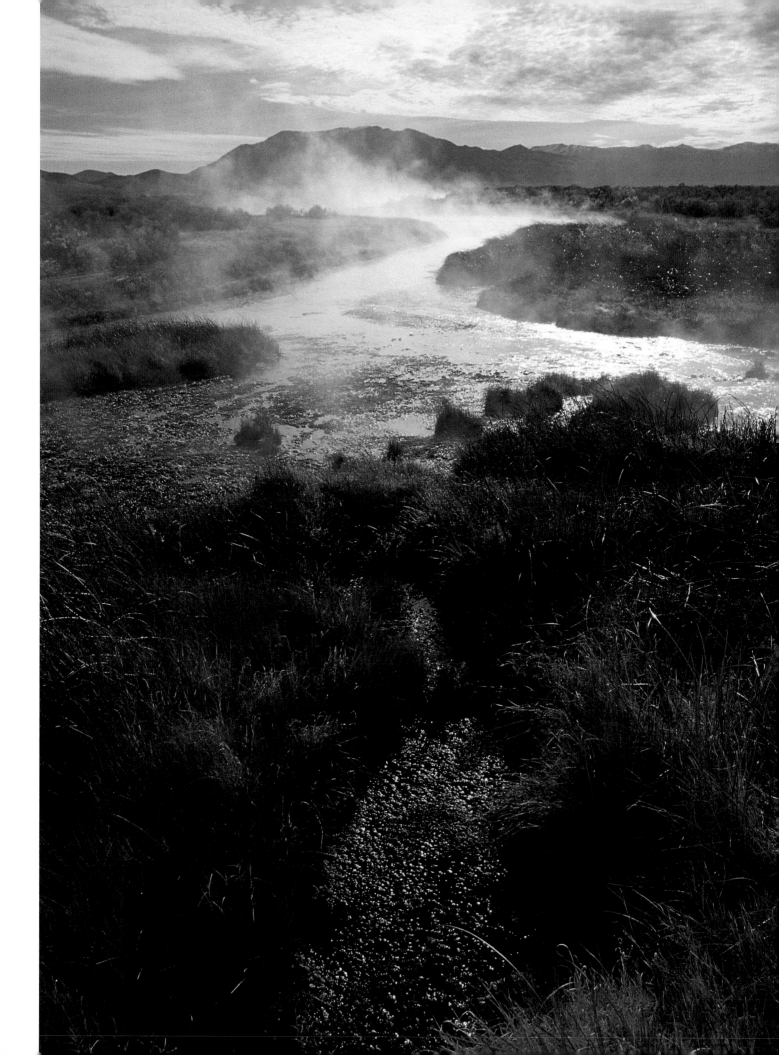

than those of us with extremely narrow ideologies—the far right and far left—the rest of us should, perhaps, meet the ranchers halfway, or nearly so. The need of the moment is to find common ground on which to work for a common good. Good-faith efforts, and a retreat from demonization and demagoguery, are what we need today.

If it makes what I have written any more palatable, let me admit where my values come from. My wife and I live in a valley along the northern end of the Colorado Front Range. Our neighbors and friends are ranching families and those who live on ranchettes.

Over the years we have come together to dance, eat, neighbor, and chart a common ground. Whether working together in our weed cooperative, developing a place-based education program in the valley school, or fencing out overgrazed riparian areas, we are working together. We want to be known more as a place where people cooperate, collaborate, and show communitarian tendencies, than as a place where they engage in ferocious combat, litigation, and confrontation. We are home, we have our hands in the soil, and our eyes on the hills that comfort us. In our imperfect lives, we work together to build a community that will sustain us and our children, for we understand that we belong to the land far more than we will ever own it. We strive together in a cooperative enterprise, to steward our lands for all of God's children and all of God's creatures. Perhaps that is why I write as I do.

Richard L. Knight is a professor of wildlife conservation at Colorado State University. His books include "Ranching West of the 100th Meridian, A New Century for Natural Resources Management," "Stewardship Across Boundaries," and "Aldo Leopold and the Ecological Conscience."

Cattle graze at the foot of Pine Forest Mountain, Humboldt County, Nevada.
© **Linda Dufurrena**

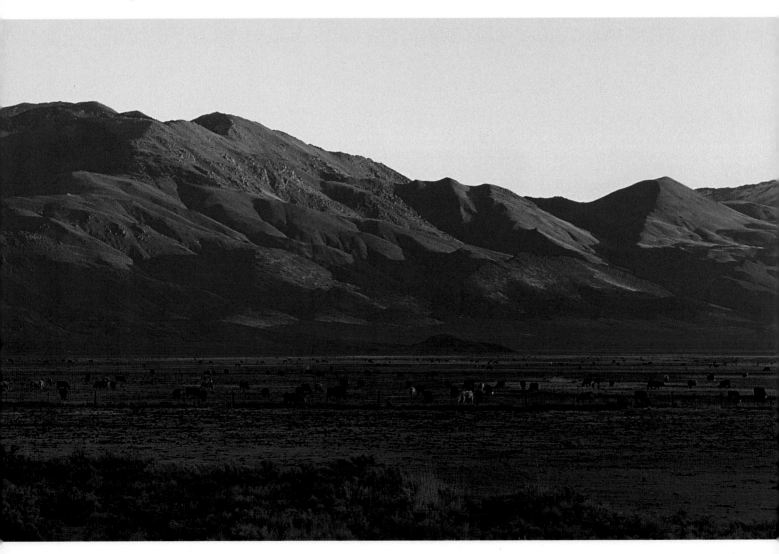

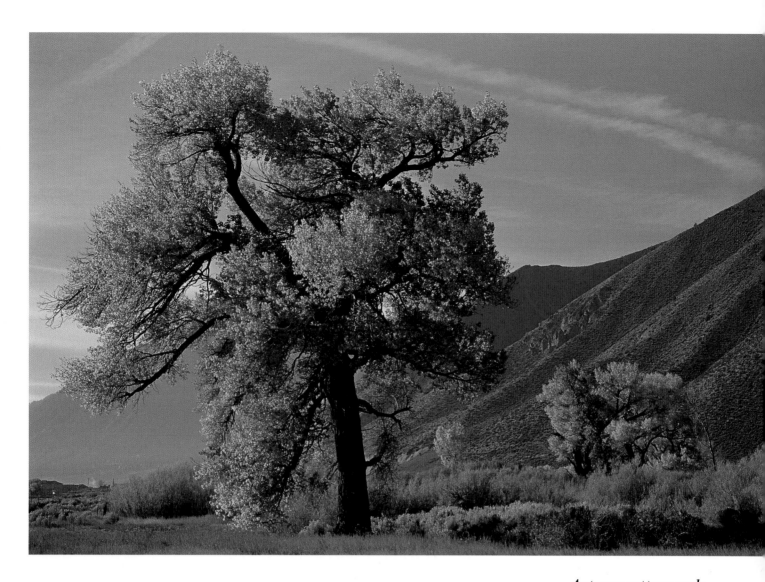

*Autumn cottonwoods
glow like gold along
the Carson River in
western Nevada.
© Larry Angier*

*Itherial's spear,
oak woodland, spring,
Ione, California.
© Larry Angier*

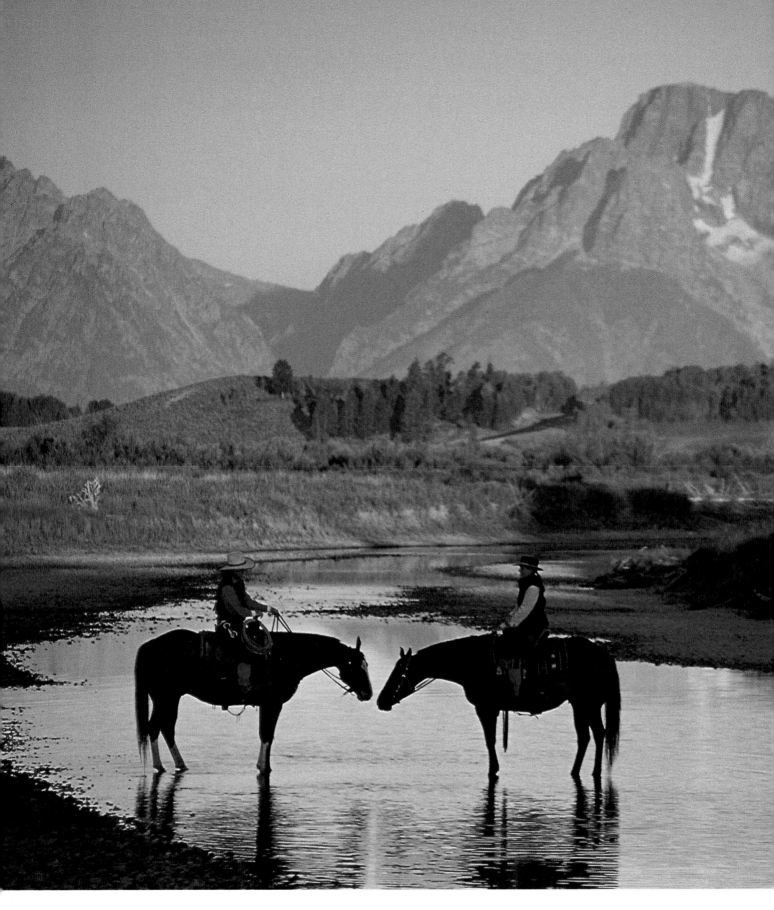

While their horses eye one another, Chris Young, left, and her daughter Betsy pause to chat at sunrise in an oxbow of the Buffalo River, Buffalo Valley, Wyoming. © *Connie Holden*

Water Poems II
By Carolyn Dufurrena

Espera, esperanza.
Esperanza,
the word for hope,
sound of softly running water.
Inside it, *espera,*
the word for wait. The old man looks
off
across the meadow,
across the years:
"I remember seven years together
when the water did not run."
Espera,
esperanza.
Wait for the water,
wait and hope.
Perhaps faith
is the echo that is left
when the memory of heaven
fades.

Sometimes you know He just has to be watching. It's His show, after all, and how could He miss a performance like this? The sky is perfectly clear, as it has been all day, but now it is as if the blue curtain has been drawn away, allowing you to look deep past this mere stage into infinity, perhaps to heaven itself.

There are so many stars glittering like handfuls of scattered jewels that it is difficult at first to concentrate on a familiar constellation. The big dipper, Orion's belt, a red shimmer from Mars. But science seems somehow inappropriate—humbled by this magnificent display. Now and then a meteor streaks across, like scratching a white streak on dark silk. It is almost too unreal to be imagined; and too real to ever be forgotton.

Everybody knows you can't see this show past the glare of even a small town's lights. You have to be out there somewhere on some lonely trail or on an old road that rambles off to nowhere. That's where He is, you are sure, because it is the best seat in the universe.

But there's another part most city folks don't see or think about either. Almost always under that great star-scattered dome, you can find the horizon by searching for where it goes truly dark, faintly etched by mountain rims. There, beyond where you even can guess it might be, is the single flicker of orange or lemon. Just a dot, really, but not a star. Surely it is the light from someone else out in this great lonesome. A cabin? A mine? Just a lamp hung on a corral? You wonder about that too.

Who is there, so far away? Do they watch, just as you do, until they fall asleep? Or is it anyone at all, nothing but forgotten light?

You cannot know. It is enough just to wonder out here where the world for a time has come down to just you, and Him, watching.

Pink wave clouds reach out at dusk, Pine Forest Range, Denio, Nevada.
© Larry Angier

INSET: Dusk settles on the glowing lodge of the Crescent H Ranch in Wilson,
located just west of Jackson, Wyoming. © Mary Steinbacher

Reading the Land

North of the Grand Canyon, in Houserock Valley, Arizona, there is a fence.
On one side, cattle have grazed for one hundred and forty years.
On the other side, the land has been "rested," ungrazed for fifty years.
There is a marked difference. It is a matter of life and death.

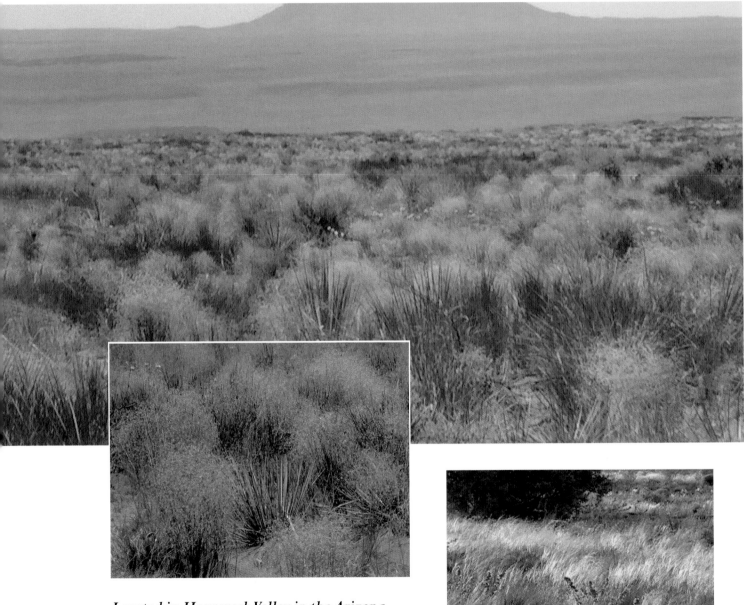

Located in Houserock Valley in the Arizona Strip, this area has over 140 years of grazing.

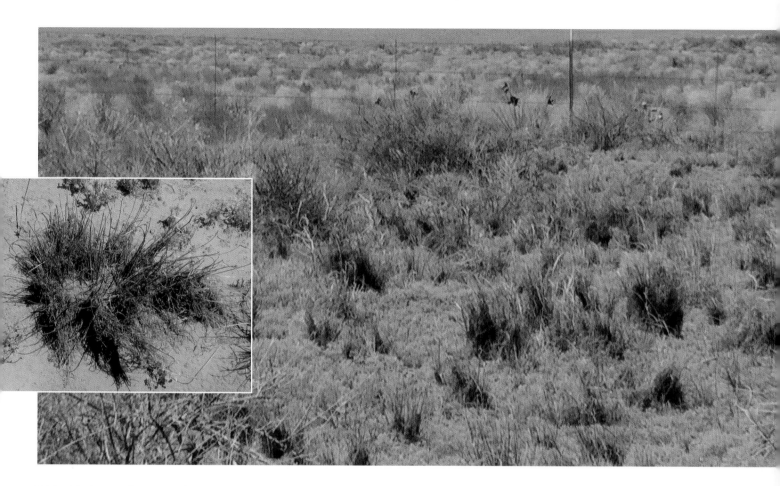

This highway "Right of Way" has been excluded from grazing since the 1950s. The foreground is the rested "Right of Way" and the background is the grazed land, showing green growth across a fence. The drought mortality on native grasses was 93.7 percent on the rested land and 9.52 percent on the grazed. These two sets of pictures were taken in spring 2004 only a few yards apart.

Where the land has been grazed (photos at left), more than ninety percent of native grasses are alive and thriving, bearing seeds for the next generation. After fifty years of rest (photos above), on the land with no livestock grazing, only six percent of the native grasses remain.

Most grass plants are born in the hoofprints of livestock. In arid rangelands like this in northern Arizona, rainfall averages eight inches a year. For the past five years, drought has cut this average in half. If the ground is not disturbed, precious rainfall quickly runs off; if hooves penetrate crust, the little holes they create concentrate water, seeds and organics.

If they're not defoliated by grazing, grasses can't survive. It's a gradual process. Old growth of prior years shades out the growth points. Eventually, the whole plant dies.

Then it gets worse. Without grass and flowers, soils degrade, losing organic matter and structure. They erode. Most rangeland shrubs and trees kill off their grass and flower neighbors as the woody plants grow closer and closer together. These are disturbance-dependant ecosystems, needing the action of hooved, grazing animals.

It's the difference between life and death. National parks that have these same soils, same climate and no grazing—Zion, Arches, Canyonlands, Capitol Reef—look like the rested side. The resource is unhealthy.

When you see ranchers, smile and wave. In our harsh western ecosystems, they're keeping nature alive.

—*Steve Rich <steve@rangelandrestoration.org>*
or <www.rangelandrestoration.org>

Cattle graze the foothills along Highway 49 between Amador City and Sutter Creek in California's gold country.
© Carolyn Fox

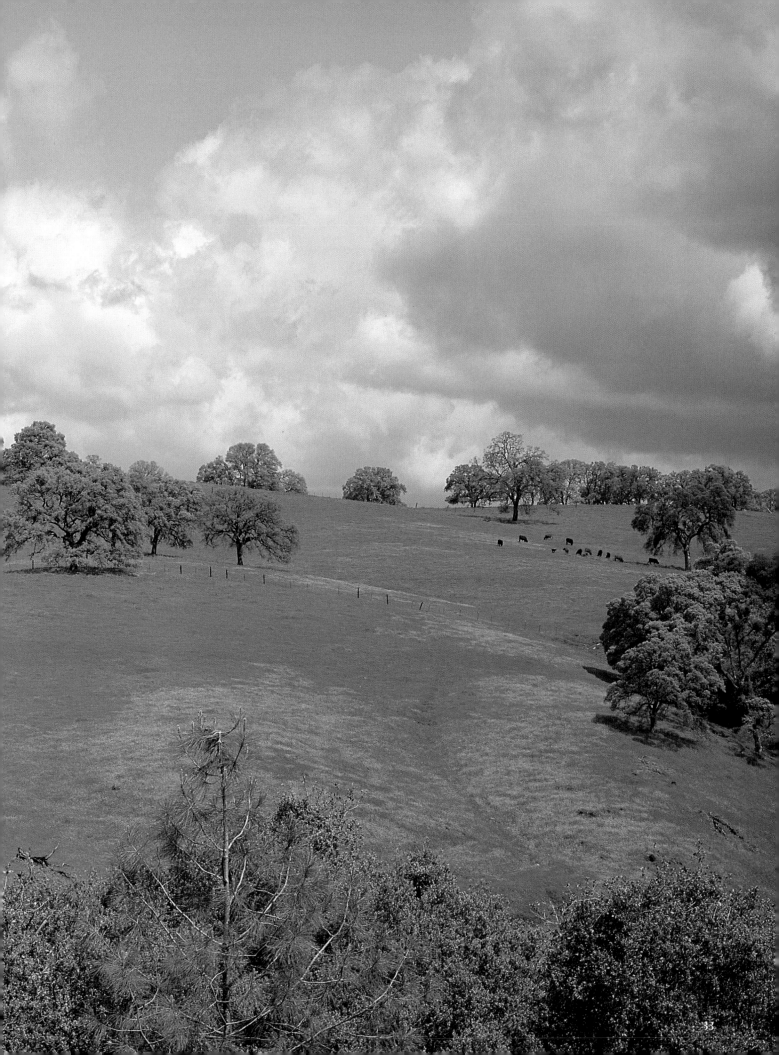

The Faces of Arizona

Santa Cruz County, along Arizona's Mexican border, is a magnet for photographer Carter Allen who finds "magic" in the mountains and grasslands, the monsoon rains and huge sunsets. Most of all, he finds inspiration in these people whose roots are often generations deep in southern Arizona soil.

"Tough as rawhide, soft as a foal's muzzle." That's Kate Ladson, who at eighteen came to Arizona to be a cowboy. Cutting horses are her forté and she's a respected hand. Grandmother Kate packs into the mountains on horseback to renew her soul. © *Carter Allen*

Born near Nogales in 1912, Manuel Heredia started working on ranches at age fourteen. The vaquero remembers, "One time I went thirty days without seeing another human being—nobody. Back then, all the work was you, your horse and a rope." © Carter Allen

Norman Hale, above, was born on his family's Arizona homestead in 1914. His first cowboy job brought in a whopping forty-five dollars a month, but he made enough to buy the U.S. Forest Service permits he needed to build a successful ranch. He feels he "should always produce something for the economy of the country, and the Forest Service people just don't have that attitude anymore." © Carter Allen

Alfredo Martinez, right, has a long list of ranches on his résumé as a freelance cowboy. He says old vaqueros like Manuel Heredia are good teachers. Known for his big black hat and winning smile, Martinez breaks horses "for fun." © Carter Allen

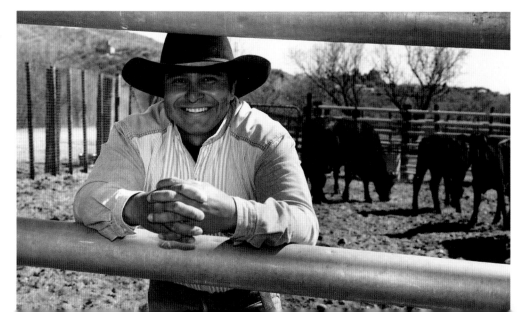

Gunfire of pillaging Mexican revolutionaries is among Helen Ellicott Ashburn's childhood memories of growing up near Patagonia. Daughter and wife of a rancher, Helen still runs cattle on her "retirement" ranch with her grandson Gooch and his wife Katie. A skilled silversmith, Gooch produces highly coveted bits, spurs and bridles. © *Carter Allen*

FROM "COWBOYS OF SANTA CRUZ COUNTY" © 1996
PHOTOS BY CARTER ALLEN,
TEXT BY DODIE ALLEN AND BRUCE ANDRE.
PUBLISHED BY CARTER ALLEN, TUCSON, ARIZONA.

Labors of Love

Etched against a light yellow sky on high barren branches of drought-weary trees are the crescent silhouettes of large birds, still sleeping. The coldest part of the night just before dawn ebbs gradually away toward sunrise. There is light enough to gather the grazing horses and saddle them. Some are nervous. Some are steady. They know their jobs and trust the ones who stroke their necks with reassurance then pull heavy on the saddle horn to check. One horse might grunt a little, telling the cowboy that the cinch is tight and comfortable. Horse and rider will become as one animal for most of the day ahead. Even dismounted, they will never be far apart. Each must trust in the other, and this is time to be certain.

West Texas cowboy turns in for the night at his range teepee. Instead of elaborate quarters, even ranch owners often retire to canvas range teepees at the end of the day during spring and fall roundup.
© *Barney Nelson*

Noon break at branding time in eastern Montana. Cindy Green hobbles her horse.
© *Barney Nelson*

On the old traditional ranches that still cover enough country to use a chuck wagon and range teepees, night is magic. Owls hoot, nighthawks boom, horses whinny, coyotes yodel. For centuries, trail drivers used stars for both direction and time. Cowboys still know how. For a while, roundup crews tell stories around the campfire. They talk about country, family, wild broncs and mishaps. They pass along the cowboy code, sometimes in rhyme or song. Soon lantern lights flicker out and the cowboy camp falls asleep to the sound of a cool evening breeze whispering through the grass that makes their life and livelihood possible.

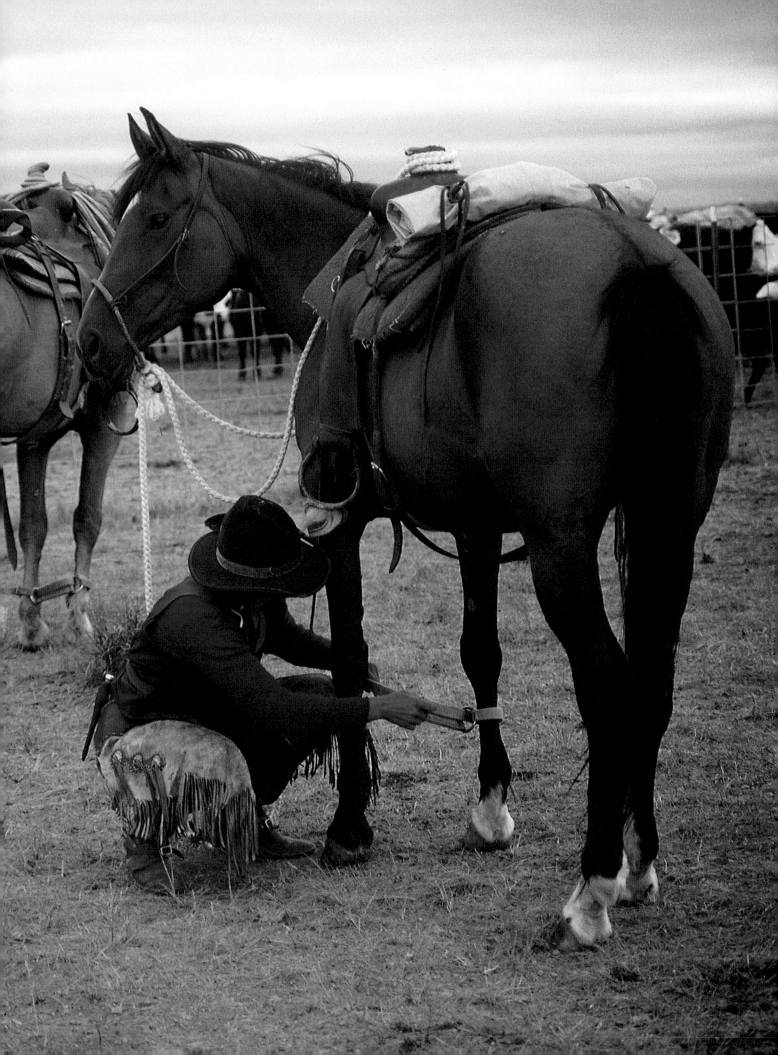

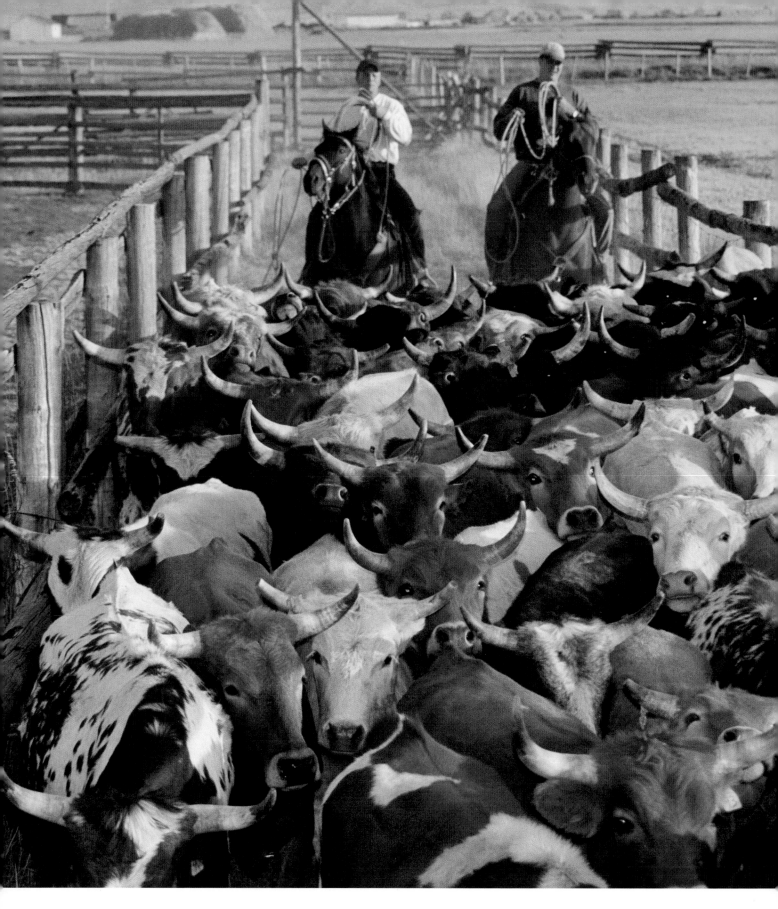

"Montana Jammin'." Montana College Rodeo participants, Kyle Greany, left, and Ty Tash move young longhorns down the alleyway at the Hirschy Arena in Jackson, Montana. They are preparing to practice roping before an upcoming event. © Cynthia Baldauf

Pat Gideon, horseshoer,
Cosentino Ranch,
Ione, California.
© Carolyn Fox

Tim Dufurrena cinches up
his bedroll for a few nights
out on the trail.
© Linda Dufurrena

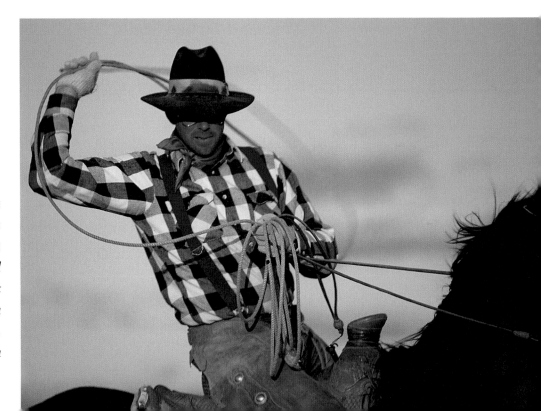

Before he became a
government trapper, John
Peter was a cowboy in
eastern Oregon. He still
helps with branding at
many northern Nevada
and Oregon cow outfits.
© Linda Dufurrena

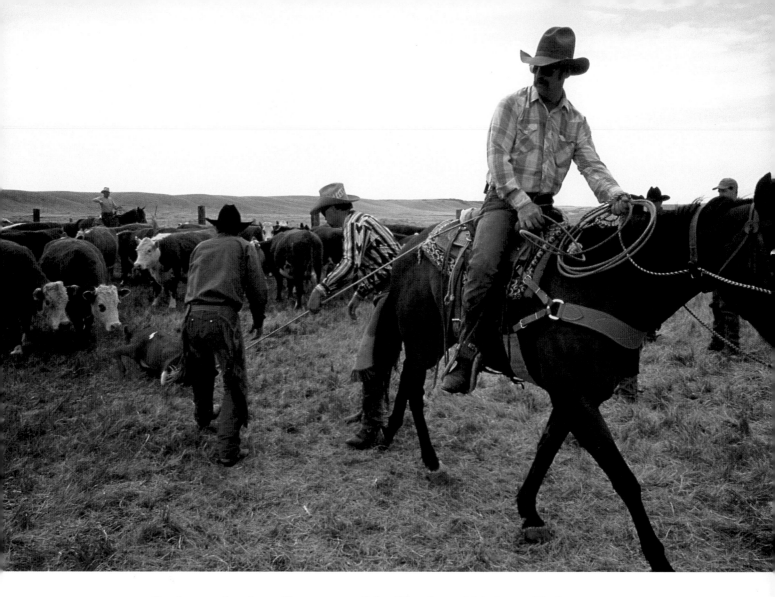

*During spring branding season, John Harris and his horse Hudson
work to pull a calf towards wrestlers, Kelly Merrick, left, and Wade
Utter. The Nimmo Ranch is located in Laramie County, Wyoming.
© Mary Steinbacher*

*An unusually wet day
at the 71 Ranch in
northeastern Nevada.
© Cynthia A. Delaney*

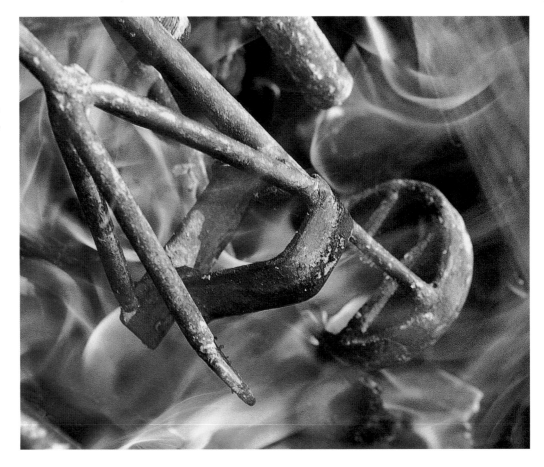

Irons in the fire.
© Michael Eller

Branding at the Marquez family's Hard Bar Ranch in San Luis Valley, Colorado. © suzanattaos

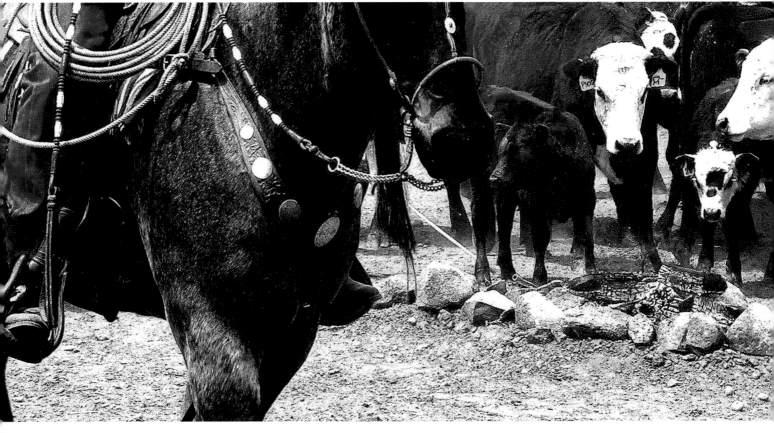

Fran Kilcrease brands and innoculates calves on the Chilicote Ranch, Valentine, Texas.
© Barney Nelson

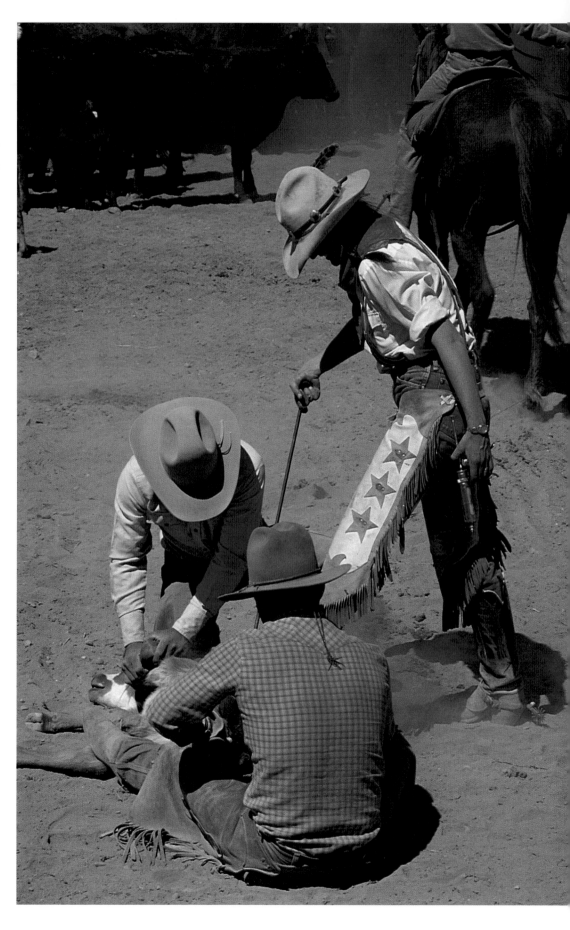

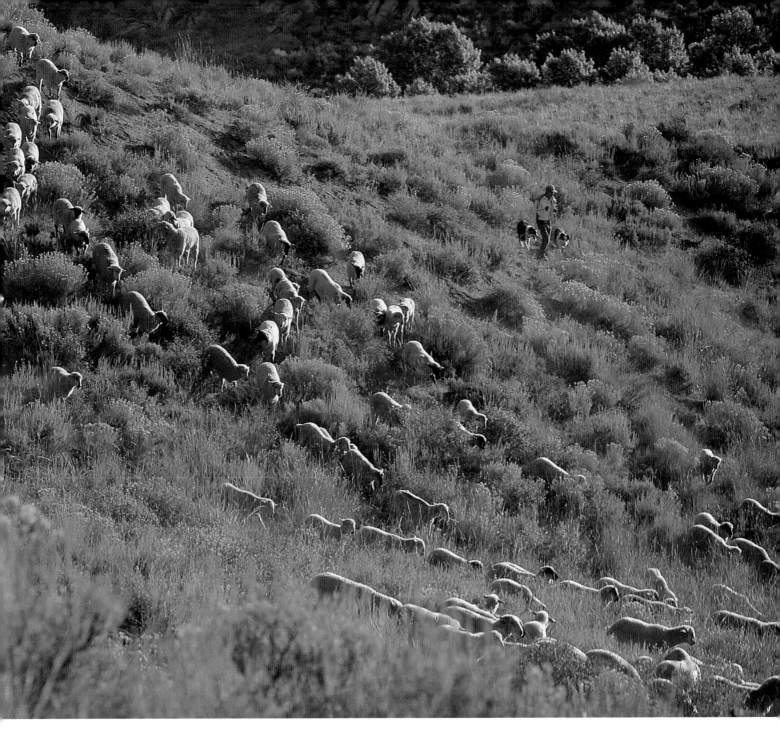

*Taking lambs from
Lovely Valley down to the
Dufurrena Ranch pasture
in late summer.*
© *Linda Dufurrena*

*Lamb at dusk bleats
for its mother.*
© *Linda Dufurrena*

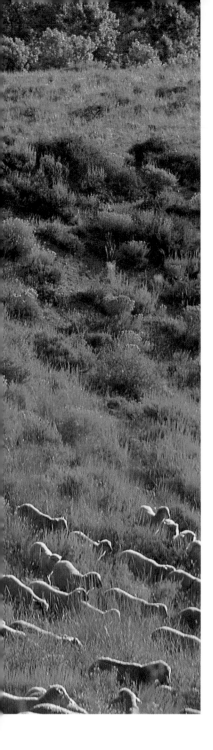

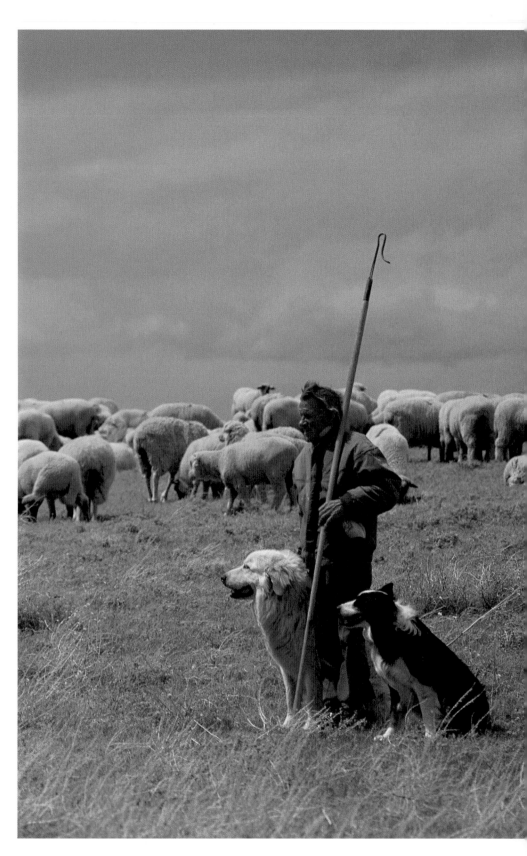

*Basque sheepherder
Señor Olcomendi, with help
from Blanco and Pinto,
guards a thousand sheep in
Antelope Valley, Los Angeles
County, California.*
© *Carolyn Fox*

Humberto Padilla moves longhorns on Willow Creek Ranch at
Hole in the Wall, Kaycee, Wyoming. The ranch lies at the southern
end of the Big Horn Mountains with elevations ranging from
5,200 to 8,200 feet. Its geography varies from flat open range,
to rolling hills, to canyon country, and on into the higher
country of the Big Horn Mountains. © Mary Steinbacher

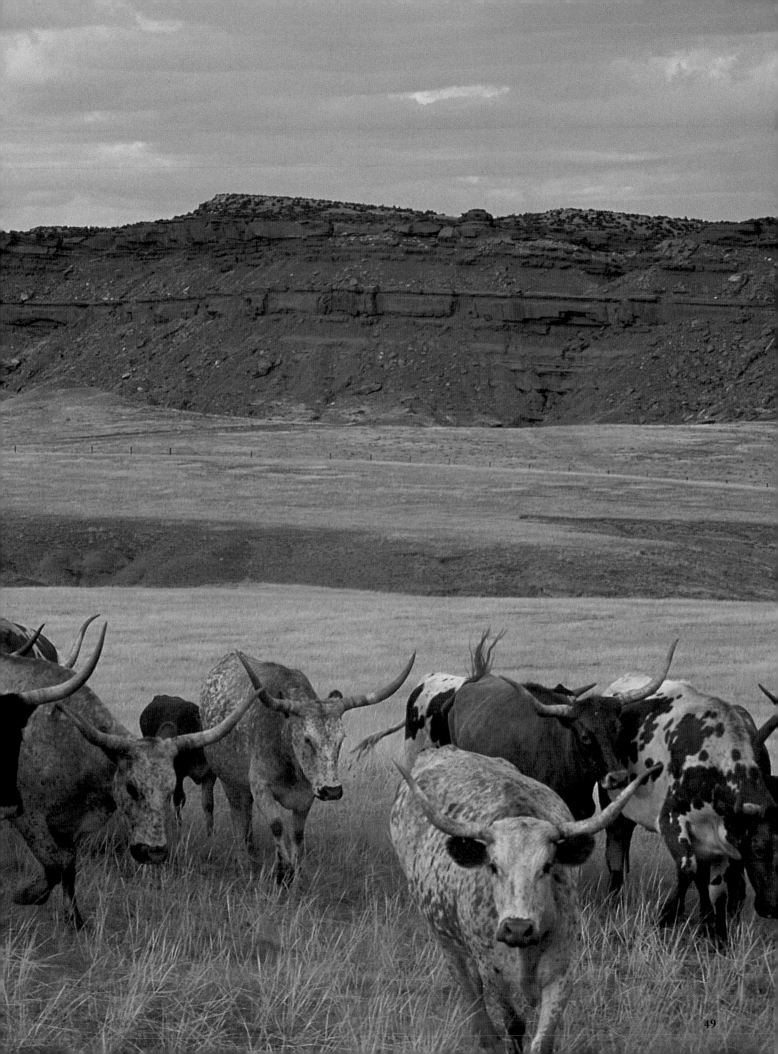

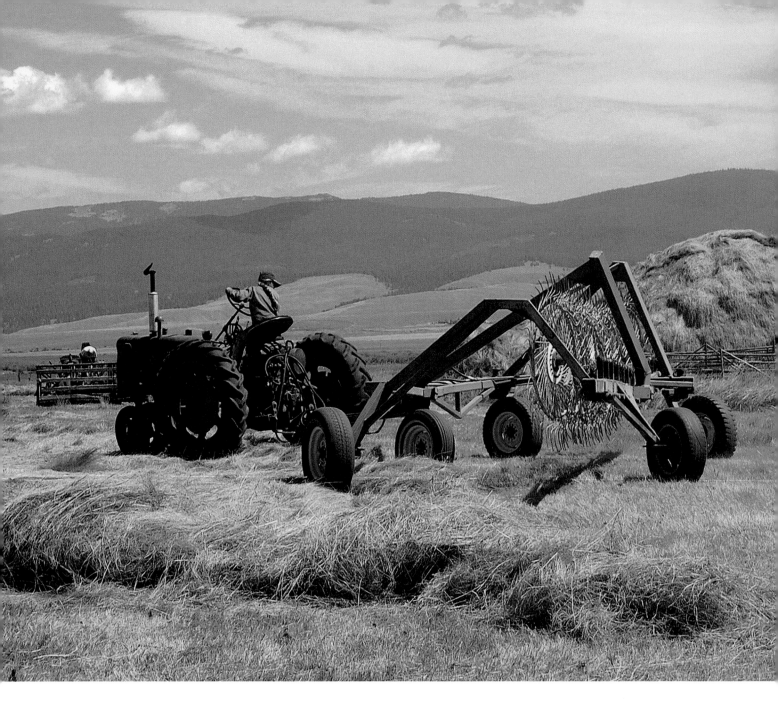

Brooke Hirschy, eleven, and her sisters represent the fourth generation of the Hirschy family ranching in the Big Hole Valley, Montana. She is driving a wheel rake. From July 15 to August 15 it is not unusual to see huge hay crews busy driving all types of ancient equipment, with some members as young as nine. The youngest usually start out operating the dump rake to pick up the scattered hay, graduate to the giant wheel rakes and several years later eventually elevate to the status of buckraker. © Cynthia Baldauf

You can't spray on the scent of a ranch at daybreak. It could never be made a perfume. The last wafting lures of bacon grease or the mellow reminder of remaining coals in the fire. Just the heat off an iron stove, or even the way an inevitable oilcloth table cover seems partial to butter and syrup. The special way strong coffee smells in a tin cup. The chicken house. A wet dog. An outhouse. Horse and hay and the drift of your own first sweat into flannel and jeans. So much of it is sensed in the nose.

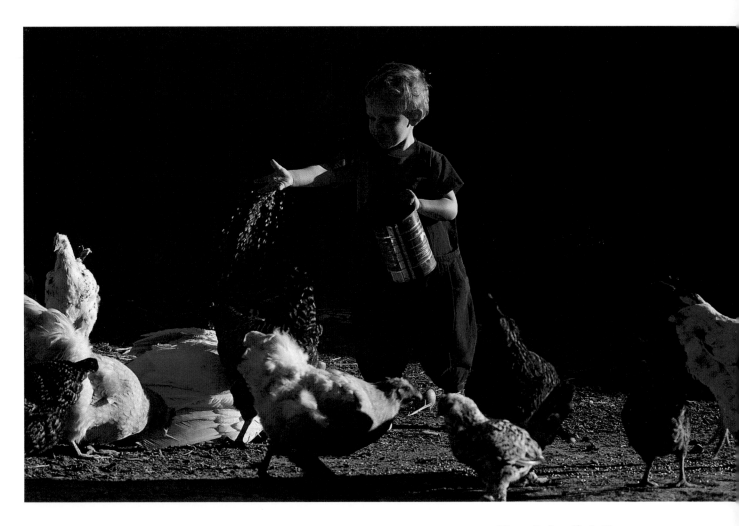

Marc Palotai's daily chore, feeding chicks, near Denio, Nevada.
© Linda Dufurrena

Ranch hand Jeremy Morris sits mounted on his horse with best friend Pita. Pregnant at the time, Pita was wet and tired from swimming back and forth across the Buffalo Fork River in Moran, Wyoming as the cowboys moved horses.
© Mary Steinbacher

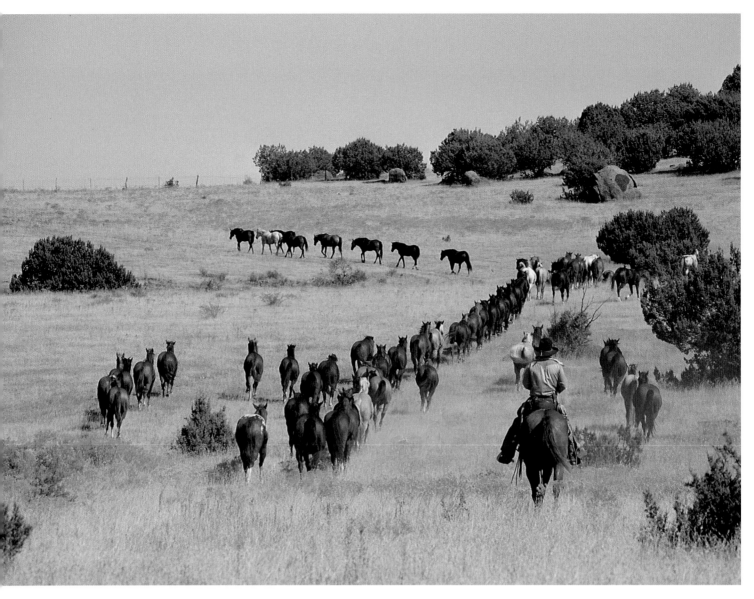

On many big Texas ranches, a working remuda is moved without the aid of machinery to the next day's location for branding or gathering. Two cowboys can move a hundred horses. © Barney Nelson

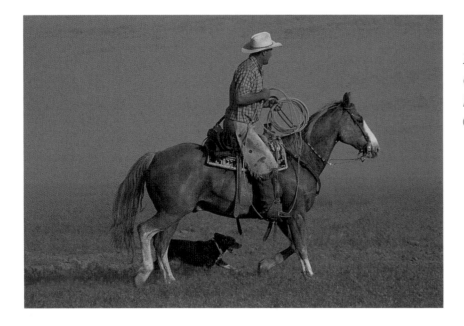

Hank Dufurrena and his dog Carl head out to gather calves for branding in northern Nevada. © Linda Dufurrena

Steve Shroder holds a reluctant colt while Roger Peters waits to brand at the Dragging Y Cattle Company in Dillon, Montana. © Guy de Galard

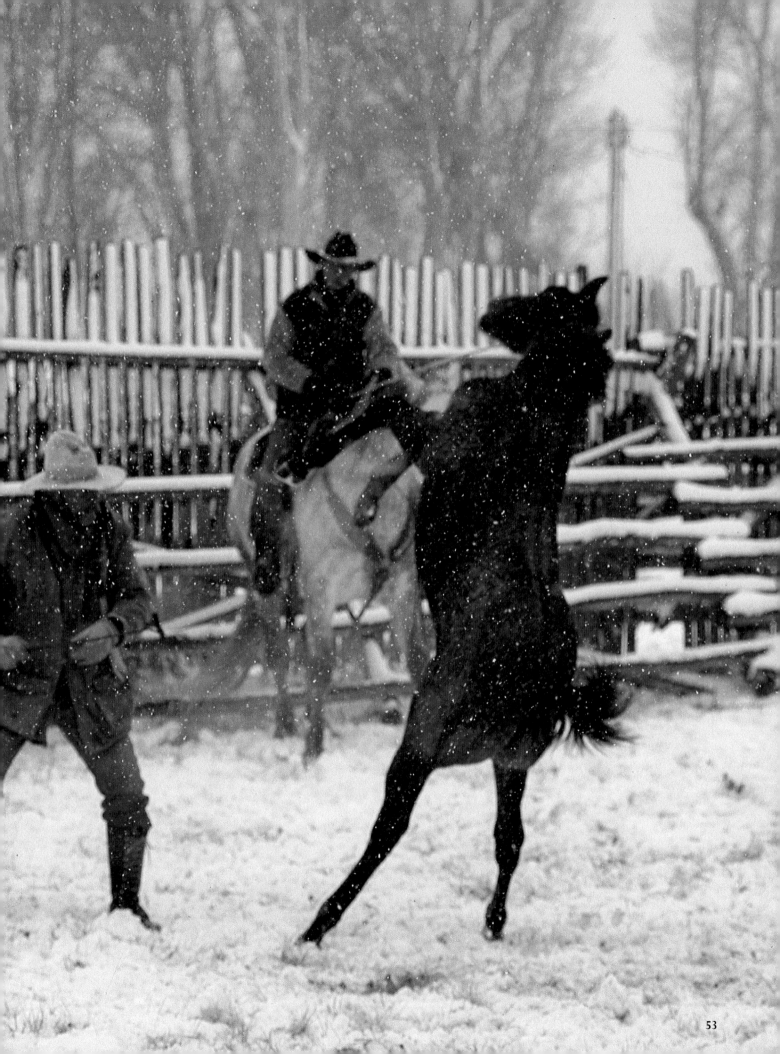

Mule skinner Ray Albiani repairs tack at the end of a pack trip, Yosemite National Park, California.
© Larry Angier

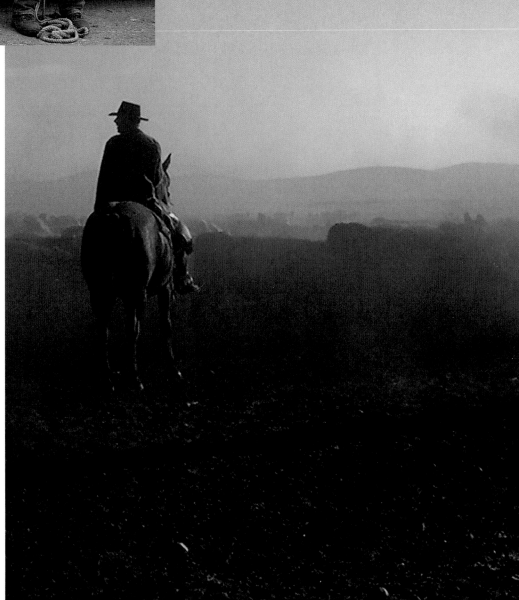

Cowboys Dan Coon and Andy Baldauf each count the herd as they enter the holding pen at the Strowbridge Ranch in Wisdom, Montana. The cattle churn the dry corral dust in early morning forming a pink cloud.
© Cynthia Baldauf

First light can come in the dim blues of deep winter or in streaks of orange at the peak of summer. It's the brightening pastel of the horizon that gives this spring away—that and the dark humid fragrance of dew in the grass.

Artists and writers and photographers depict these ritual moments, but they seldom can touch on the strongest sense that is there in the dim light before even birds break the silence. It is the smell of worked leather blending between horse and man—a creaking, confident aroma maybe a little like your old baseball glove, but not at all so stiff as the "new car smell" that sells another way.

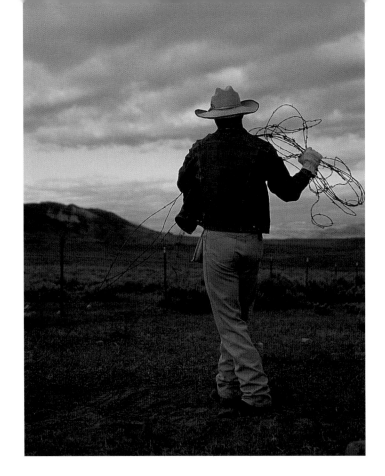

Ranch hand Michael Hart winds barbed wire after he and two other hands rewired a ranch gate in minutes. A part of the True Ranches, the VR Ranch is south of Glen Rock, Wyoming and has been recognized by the Wyoming Game & Fish for incorporating wildlife management measures into the day-to-day cattle operations and for contributions for the betterment of Wyoming's wildlife resources.
© Mary Steinbacher

Sitting deep in native grasses, Greg Locke checks his saddle for the next day's ride. The West Texas cowboys are gathering cattle to ship. © Barney Nelson

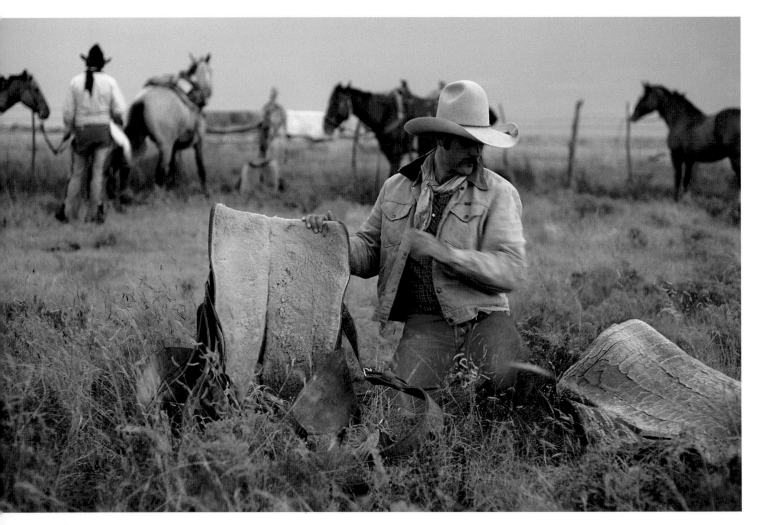

Traveling cowboy cook, Dancer Davis, checks his baking cornbread over a campfire while working an event at the Diamond Cross Ranch in Moran, Wyoming. The ranch, located north of Jackson, Wyoming and near Teton and Yellowstone National Parks, is host to ranch rodeos, horse training demonstrations and trail rides. © *Mary Steinbacher*

Faced with long, hungry days far from any human habitation in 1866, Charles Goodnight rebuilt an army surplus Studebaker wagon to create the first chuck wagon, named for the cut of beef we still call "chuck." It was designed to provide victuals for the wranglers who pushed cattle along the Goodnight-Loving trail from Young County, Texas to Fort Sumner, New Mexico and on to Colorado. For the first time, the cowhand didn't need to rely on what he could carry to sustain him on the trail. Goodnight's chuck box had shelves, drawers and a drop-down lid that became cookie's work surface. Two days' water supply rode in a barrel attached to the side of the wagon and a canvas sling underneath was used to carry whatever fuel cookie could gather as they rode. Stuffed into the wagon were food for the men, feed for the horses, and bedrolls and gear for the cowboys.

Sunrise, Triangle X Ranch, Moose, Wyoming.
The horses are gathered from their pasture to
be selected and saddled for the day's work.
© Connie Holden

Legacy of Iron Man

Andrew Maneotis was a man made of iron, who walked the tall mountains alone, who went from can't to can in just a few short years. He came to America with little more than hope, seeking nothing more than a chance to make good, and died a ninety-five-year-old man who'd made something from nothing.

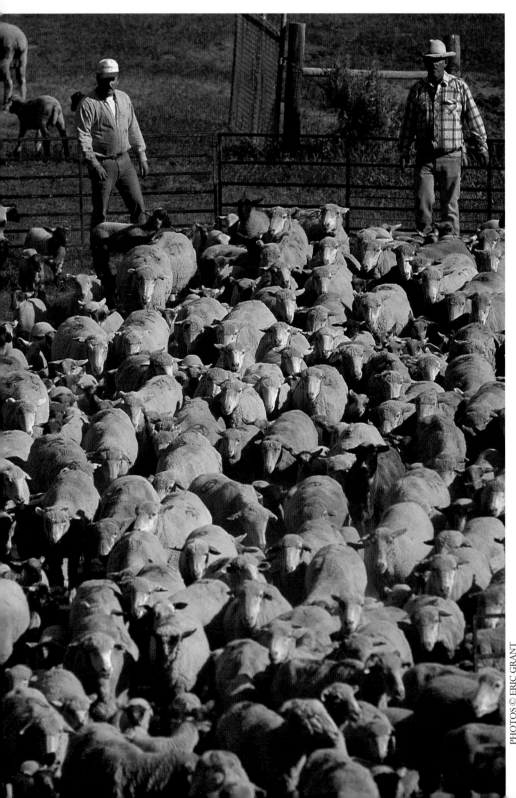

PHOTOS © ERIC GRANT

Andrew Maneotis,

a native of Greece, arrived in the states in 1918, leaving behind a continent ravaged by war. He joined his brother in the coal mines of Utah. He missed the sun-drenched days, however, the summer breeze, and mostly the livestock so he took a job in southern Utah working for a Frenchman who paid him in sheep, not cash. Within four years, he pieced together eight hundred ewes.

Andrew pushed his band of sheep into northwestern Colorado, where he found good feed, good water, and plenty of people who didn't want him there. The cowboys had fought for years to keep the sheep off the range, and they especially disliked foreign sheepmen. They killed his sheep. They dragged him with a rope. They beat him up. They blew up his house with dynamite. They shot him in the face, leaving him permanently blind in one eye. But they could not break him or make him leave.

In the upper reaches of the Yampa River Valley, the mountains were quiet, and he found peace beneath the quaking aspen and the cool, dark timber. And, on summer grasses, his lambs grew fat and heavy.

When the Great Depression began, he had enough cash to buy up many of his bankrupt neighbors' properties and built his operation into one of the valley's finest.

"Dad had no hobbies, no other interests, than his sheep," says Tom

Maneotis, who continues to run his father's operation with three brothers; John, Andy and Tony. "The sheep were everything to him."

The Maneotis Sheep Company is one of the last-surviving migratory sheep operations in Colorado. Each year after the snow melts, they move their eight thousand ewes up from the red desert of northwest Colorado or from the cornstalk fields near Denver, onto the oak brush hillsides in spring, and then into the high mountains near Rabbit Ears Pass in summer. They follow many of the same trails and graze the same meadows that Andrew did a generation before them.—*Eric Grant*

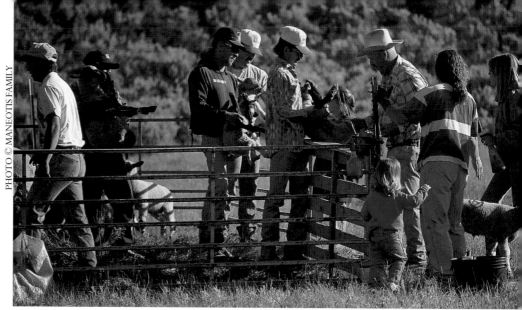

Several generations of the Maneotis family gather with sheepherders and friends for sheep marking in spring. Lambs are castrated, docked, innoculated and counted. Many ewes have twins and can care for them but the weakest of a triplet birth (a bummer) goes to the ranch for hand-feeding.

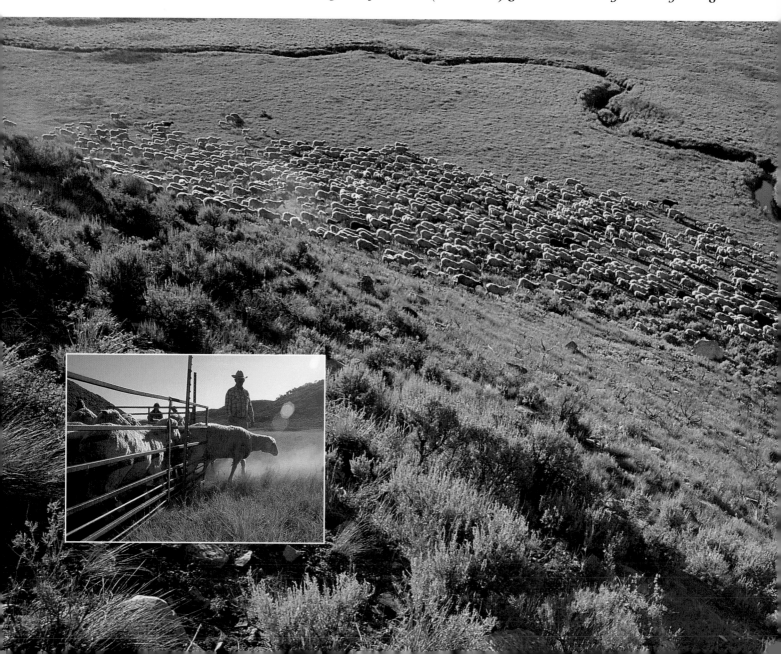

Country Schools & Cowcalfitis

It could be the Sandhills of Nebraska, Wyoming's Red Desert, or the mountain valleys of Montana. A little yellow bus rumbles down the road to a small square building, sitting by itself on the valley floor. There are no barns or outbuildings, just a flagpole and maybe a set of swings.

Children pile out of the bus to play in the yard, while the driver may walk over, unlock the door and drop her briefcase on the big desk in

Virginia City, Nevada.
© *John Bardwell*

the corner to get ready for the day's lessons. The day begins, not with the jangle of automated bells and intercom announcement, but with a whistle, the teacher's silhouette in the door. "Come on in kids; let's get started."

Jackets hung, drinks from the sink, and the handful of students, all shapes and sizes, sort themselves into desks around a classroom that most educators simply shake their heads at.

"How do you do that, teach three (or four, or eight) grades at once?" they ask.

The teacher smiles, and says, "The kids learn to be independent, and they help each other a lot."

There are few interruptions, just the books and maps and the big wide world outside from which to learn, and the quiet time that kids need to think about the things they learn.

There may be seven or ten or maybe twenty kids to a school that spans eight grades and kindergarten. It's not so unusual to be the only one in your grade all the way through. The teacher may live next door, or be the wife of the neighboring rancher. She might be your aunt, or your grandmother. She will be the music teacher, the art teacher, the computer tech, the janitor, and the principal most days.

A fourth grader reads to the little ones as the teacher works with the seventh grader at the table in the back; someone's mom stops by on the way to town to help the little group learning their multiplication tables. Pairs of heads lean together, quietly working out problems.

The creek outside and the pasture it runs through are the living lab, with stone flies and scary fingernail-size invertebrates waiting to be captured, studied and turned loose as the students watch nature's tiny ruthless battles play out in the classroom aquarium. They learn about the place they live from the guts of it to the stories their grandfathers tell at the Christmas program.

People stop in, and an impromptu lesson in biology is easy to accommodate. The principal at our two-room school in King's River Valley, Nevada, drops by one winter day with a friend, a falconer training two young peregrines.

The kids pile onto the rug, wide-eyed, and watch as the falconer lifts the hood from the raptor's hunter eyes. Peregrines are common in our

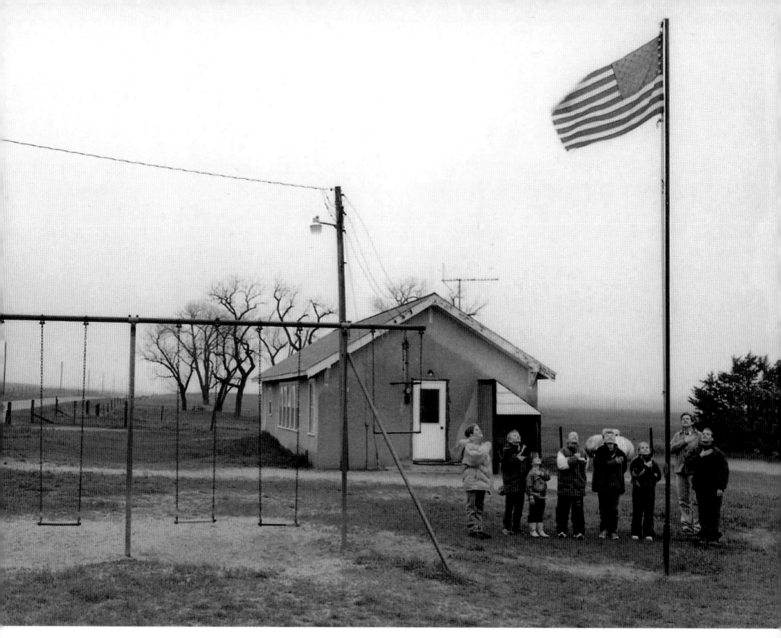

part of the world, but none of us has seen one at this range. The young female spreads her wings and would fly around the little classroom if she could. She glares ferociously at the primary students. The falconer takes the kids outside to watch as he returns her to a perch in the camper of his pickup truck, and feeds her morsels of something she can tear apart. It's an instant biology lesson, one the kids will remember a long time, and an experience they'd never have in town.

In spring, we watch as a buckaroo crew brings a bunch of cows and calves down the canyon toward our little group as we gather plants and creatures for the classroom aquari-um. Hunker down, everybody, I tell the little ones, and be still. The cow-boys maneuver the herd between us and the bus parked a quarter mile away, over on the road. We watch as the buckaroos let a couple of cows go back for their calves, stashed under the sagebrush, and then we watch as they catch up with the rest of the herd. Another lesson.

Branding season arrives in May. Teachers get unusual notes from parents. "Mary has developed a terrible case of cowcalfitis. She will be home two days this week; this condition may recur without warning all this month." This other work of theirs is important, too. They learn young what work really is, and they keep

Sybrant Public School, Bassett, Nebraska. Seven pupils, K-8.
© Charles W. Guildner

their homework current.

The country school, in spite of budget cuts, federal legislation, and politics, is still around, quietly giving ranchers' kids an education that everybody admits is better than the one they can get in town. Next time there's a program or an ice cream social at a country school near you, stop in. The kids are polite, the ice cream might even be homemade, and you might find yourself, for an hour, part of the village it takes to raise a child.—*Carolyn Dufurrena*

Friends of the Family

The gelding recognizes you and flares his nostrils as you toss the rein across his neck. The stirrup suits you, but your lazy left leg always needs coaxing for that first big step as you swing into the saddle. The dog is waiting. Together, you take a deep lungful of dawn just in time to hear the doves begin their mournful cry.

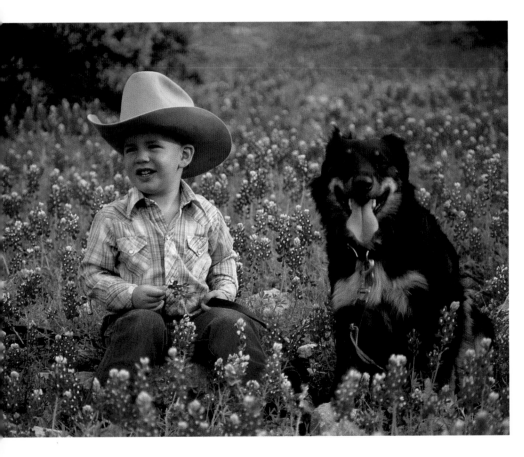

Like pinching back your garden flowers, sheep grazing causes a profusion of wildflowers every spring in Ozona, Texas on the Allen Ranch. Here four-year-old Ty and his hardworking sheepdog Luther Bob play in the Texas bluebonnets.
© *Barney Nelson*

"Nosy," the soft hairy muzzle of a curious horse in the Home Ranch remuda, Clark, Colorado. © Cynthia Baldauf

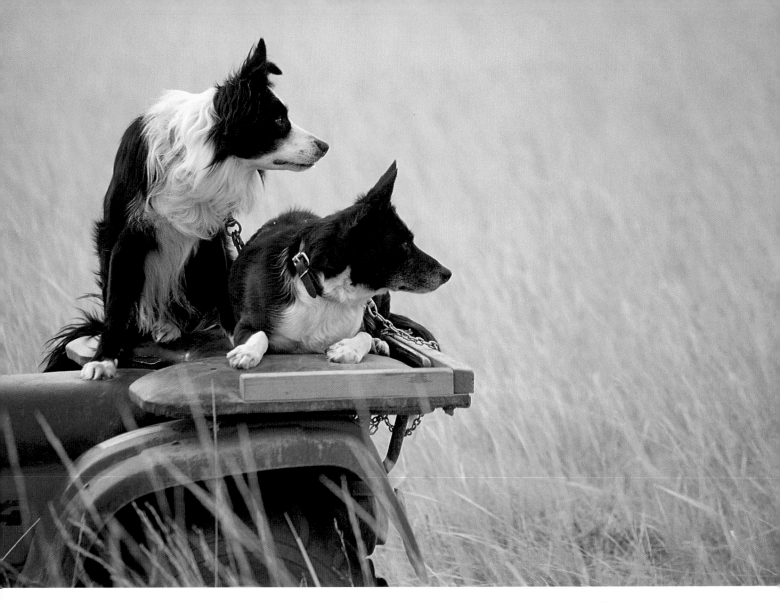

Sheepdogs on the back of a four-wheeler, eager to roll as soon as they are released. © *Chad Harder*

Six-year-old Tori Bonham, with her hat drawn low, waits with her horse as riders prepare to work cattle at the XX Ranch in Tie Siding, Wyoming. The ranch, at an elevation of nearly 8,000 feet, lies southeast of Laramie.
© *Mary Steinbacher*

Becky Prunty on Pat, Prunty Ranch, Charleston, Nevada. Prunty horses are famous for their color and stamina.
© *Guy de Galard*

Kyle Bohling and friend.
© Heidi Vetter

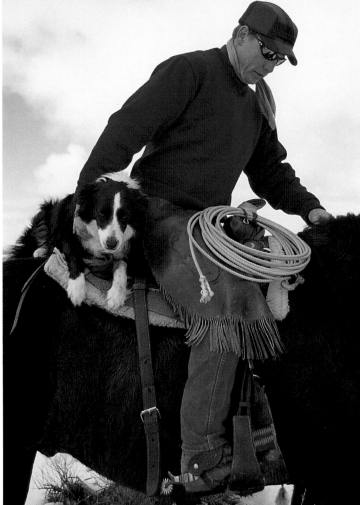

Buckaroo vet Rich Long and his
border collie, after a cattle drive on
the ZX Ranch, Paisley, Oregon.
© Larry Turner

"Reflection." The black-and-white paint was waiting his turn in the bucking chute at the Buffalo, Wyoming, County Fair. Look closely and you can see a four horse trailer reflected in his eye.
© Cynthia Baldauf

"Truce." Just after a May snow, border collie Fly keeps her eye on Jocko trying to decide whether to "drive" him to another location. Eventually she declares a "truce" and lets him rest. The Daniels Ranch, Wisdom, Montana. © Cynthia Baldauf

Zackary Dufurrena helps Grandma feed bummer lamb. © Linda Dufurrena

Grady Nelson saddles up for a winter ride. Wildlife survive because of the private lands on western ranches. This mule deer knows where it can get some grub in West Texas. © Barney Nelson

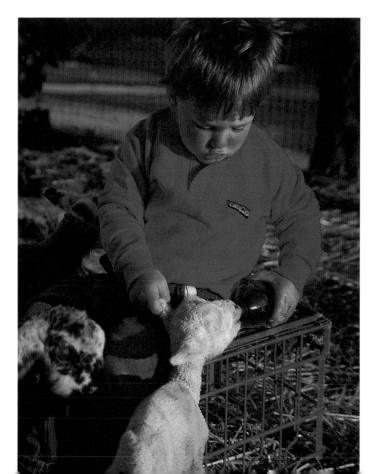

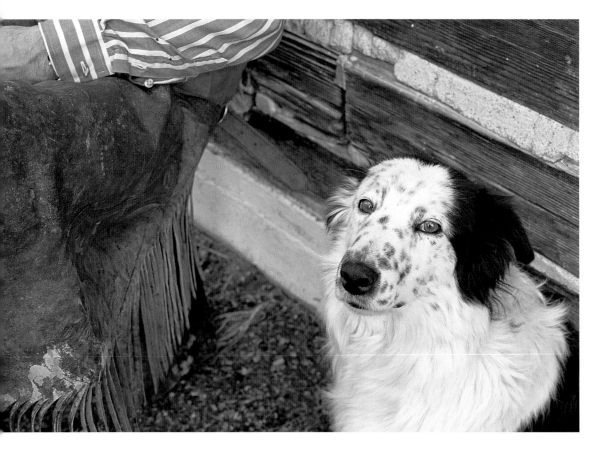

Freckles rests beside his master Scott Satterthwaite at the old barn on the 71 Ranch near Elko, Nevada.
© *Cynthia A. Delaney*

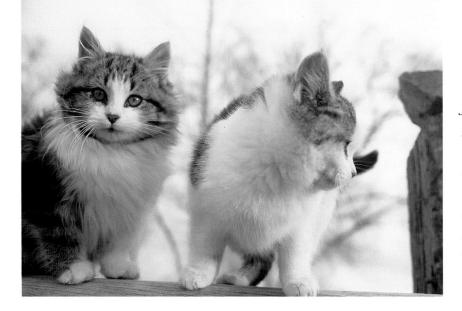

Two kittens peer out at the winter landscape from the safety of a pasture fence near Winnemucca, Nevada. Pretty soon they will be doing essential ranch work—catching rodents and snakes.
© *Cynthia A. Delaney*

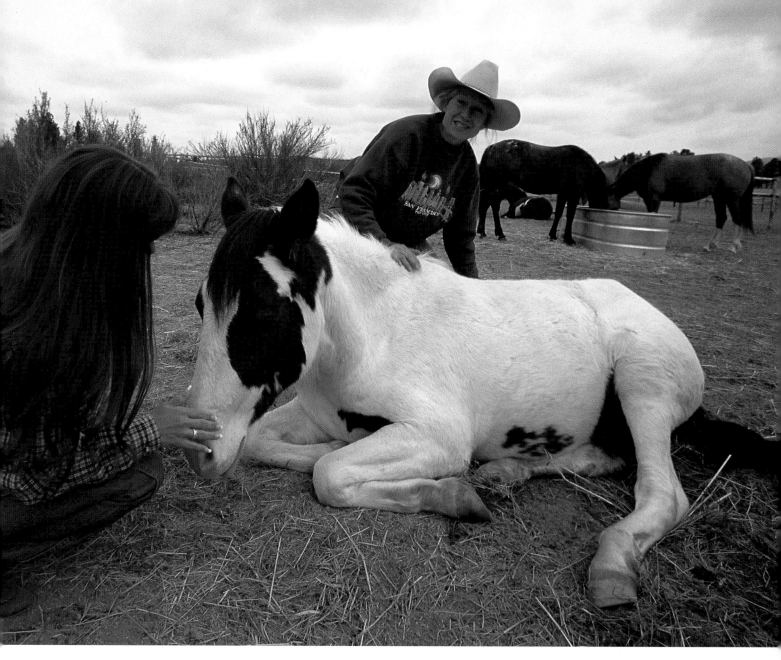

Tammie Miranda and Tana Rains shower affection on a new friend. © *Larry Turner*

Joy Crawford raises sheep and border collies on the Crawford Ranch near the Missouri Breaks in Lana, Montana. © *Chad Harder*

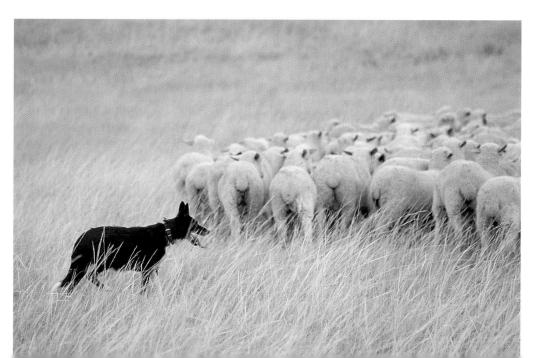

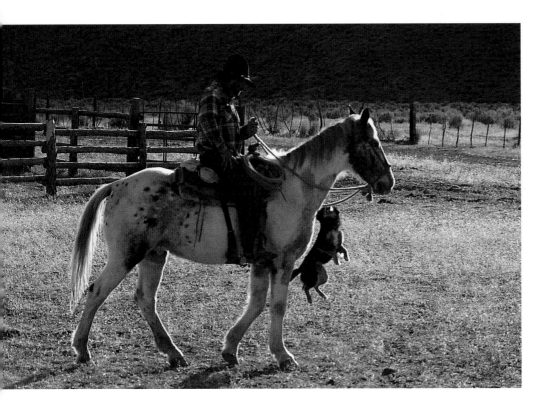

Tim Dufurrena and his dog Pepper, rarin' to go.
© Linda Dufurrena

Charlie Walden and a horse are looking for supper at last light in West Texas.
© Bob Moorhouse

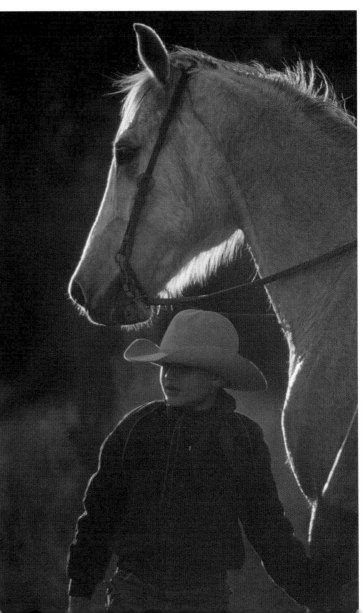

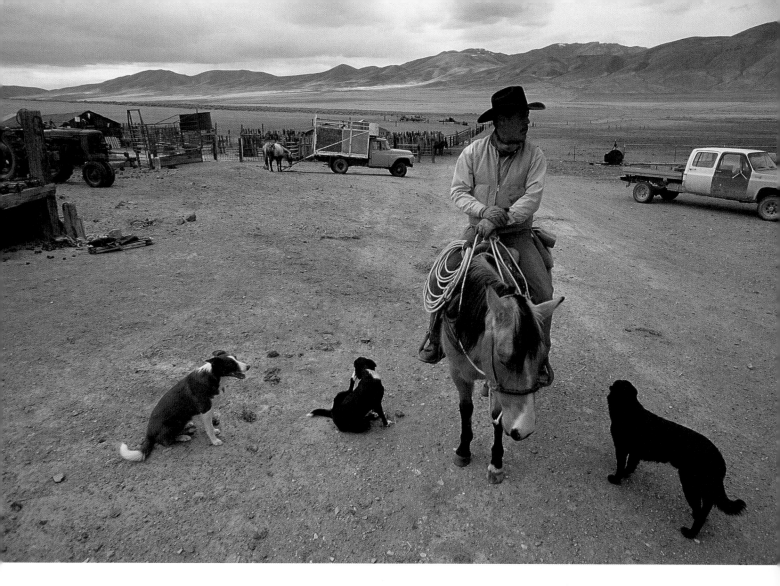

*Roger Johnson and three
companions at the Spur
Cross Ranch, Nevada,
get ready for a late
winter roundup.*
© *Larry Turner*

*Friends, Summerville,
Oregon. Shortly after it was
weaned, a guard-dog pup
adopted this buck.*
© *Don Mills*

Ranch hand Clarence Brown of the Arapahoe Ranch moves cattle on a September drive in the hills south of Thermopolis, Wyoming. The ranch is located in the vast 380,000-acre expanse of high desert, mountain country spanning the Owl Creek Mountains ranging up over 9,000 feet. Ranching operations include cow-calf-yearling cattle herds and an acclaimed quarter horse program. © Mary Steinbacher

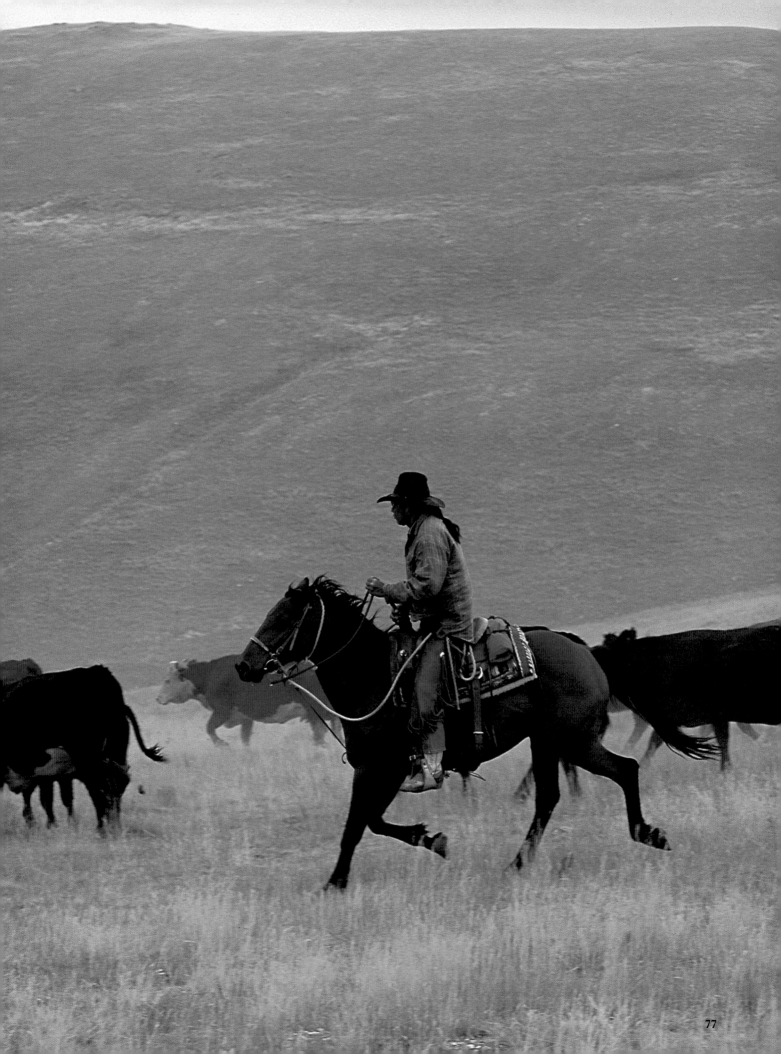

Chicken Dreams

By Carolyn Dufurrena
Monoprints © Teresa Jordan

Snow blows sideways off and on all day. Nothing is really sticking; it's just winter blowing itself out. Inside the quiet of the morning ranch house, seventeen baby chicks scrabble in a cardboard box on the burgundy carpet of my office. I have discovered a set of weathered deer antlers somebody brought home last fall, and it is in the box too, for the balls of fluff to practice roosting. A heat lamp clamps the edge of my old drafting table, shining down on them, maintaining a constant temperature. It is important that they not get too cold, or too hot, in this fragile state of their chicken lives.

The chicks are starting to feather out—white, red, yellow, black. I have several different breeds this time, to entertain my little niece from Virginia who will be coming to visit in the summer. There will be the dependable egg layers, Barred Rocks and Rhode Island Reds, but this year I have splurged on Silkies, red and blue, with goofy-looking feathers on their heads like Louella Parsons' hats. There are Auracanas, which lay pastel-colored eggs, Speckled Wyandottes, and the ones with feathers on their feet. It will be the multicultural chicken menagerie of the neighborhood. The chicks have cost me nearly fifty dollars. My neighbors would find this an outrageous expenditure: the common breeds are a dollar and twenty-five cents apiece. These have averaged close to three dollars. I am disproportionately excited.

Of course, the chicks travel with me, back and forth to town. From Monday through Friday they live on the washing machine in my tiny galley kitchen in Winnemucca, Nevada. My two cats are fascinated by the peeping and scratching that comes from the cardboard box under the heat lamp. I have had serious talks with both of them, and they know it is unacceptable to reach in, even once, with talons stretched.

The fledglings make the weekend pilgrimage to the ranch in the backseat of the old silver Caddy. Sleek, gray-leather seats cushion their traveling home, towel-draped against the cold. The sack of chick starter, heat lamp and watering dish are lumped on the floor with bills to be paid, Sam's boots and calculus homework.

The dryer hums and thumps, its low cadence companion to the humid silence. The bigger chicks stretch their long, prehistoric necks, always looking up and out of their cardboard prison, conscious of the larger world outside. *It's too cold to let them out*, I think, watching. They eat. They deposit little wet blobs behind them, tilt water droplets down their throats. They nap under the light, learn to climb the antlers. They hop to the highest tines to fluff out near their artificial sun.

They don't have the roosting thing down yet, though. As they fall asleep, their knobby heads drop slowly forward, like old men snoozing on their chins (except, of course, they have no chins). Their beaks sink, slower and slower, until they touch the newspaper. They sleep like that, balanced on the pinpoint of their noses. Breathing makes them sway gently back and forth. If they are perching on the antlers, their beaks drop until they lose their equilibrium and fall off on their little heads. Indignant, they fluff up, look around to see who saw, and settle back into their chicken dreams.

It still feels like winter when we begin the work of spring, just as everything we do in summer calls the autumn, and autumn in turn prepares for winter. Just when I think winter will never end, the planet shifts a bit, the sun stays high a moment longer. Snow in the high country sags, a trickle of moisture starts out. By the first of April, the chicks come into the feed store: my promise to myself that spring will come.

Women's Work

Ranch women thrive on the outdoors. They like the clean, fresh air and the sense of freedom and the sights and sounds of their vast western landscapes. They also work outside because they know that their work is essential to the success and survival of their family ranches. Contrary to public opinion, most ranchers are land poor and can only dream of being money rich. They depend on the work of the entire family to survive and prosper.

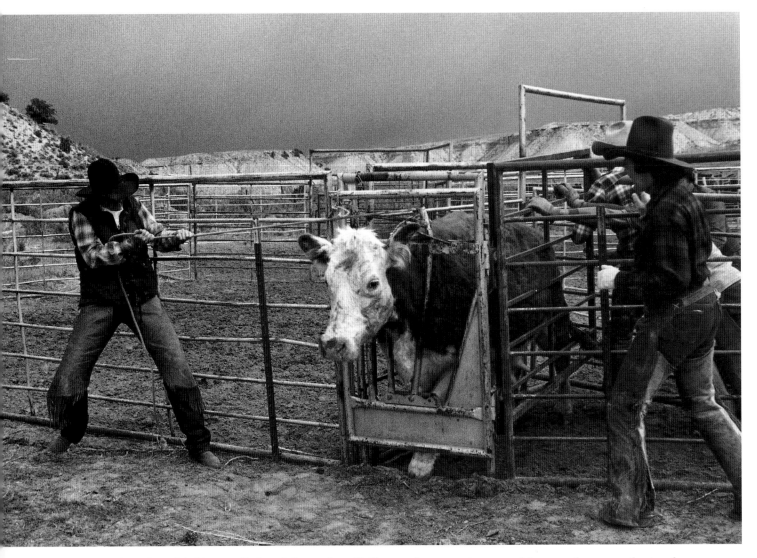

DeeDee Dickinson, left, with mother Polly getting cow in stanchion so they can doctor her, Vermillion Ranch, Colorado. The ranch straddles the extreme southwestern part of Wyoming at the corners of Colorado and Utah. DeeDee says, "It's a hard, harsh life, but the short time you have together, if you make the most of it, it's gratifying."

EXCERPTED FROM "HARD TWIST, WESTERN RANCH WOMEN" BY BARBARA VAN CLEVE, MUSEUM OF NEW MEXICO PRESS, SANTA FE © 1995.

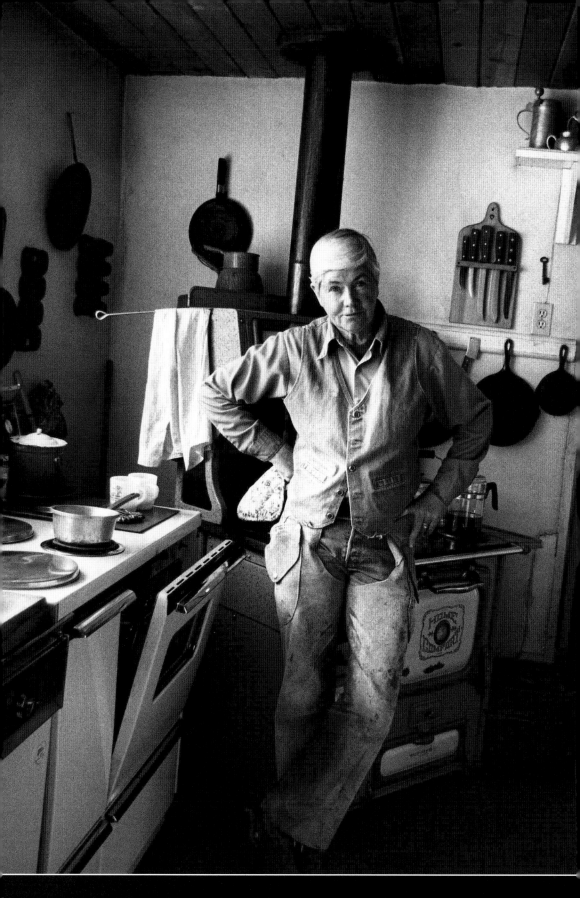

Gretchen Sammis, Chase Ranch, New Mexico. "Sometimes when it's twenty degrees below,
snow on the ground and calves coming, I know I had rocks in my head to give up teaching

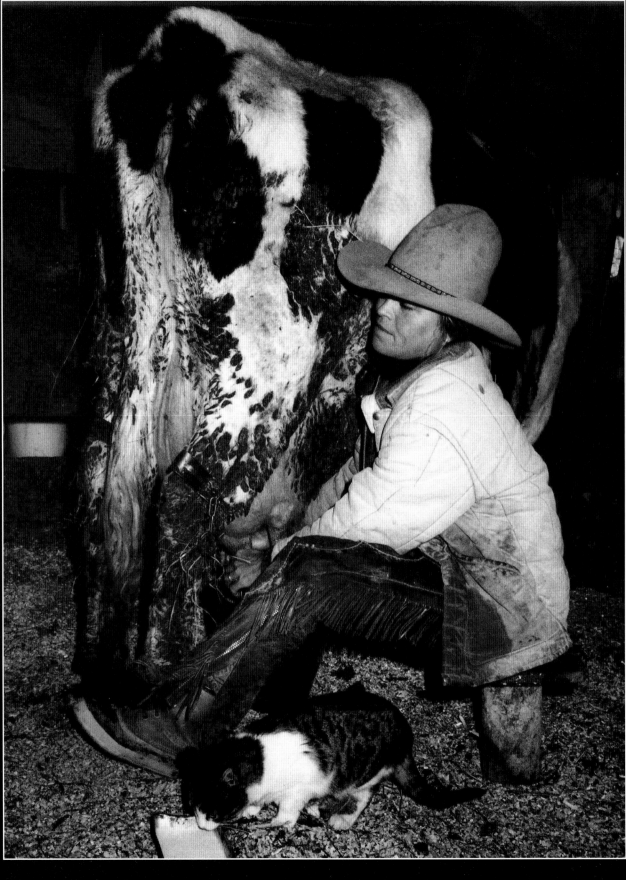

Melody Harding, Bar Cross Ranch, Wyoming. "Milking is my thinking time. I can get everything all straight in my mind. It's kind of the beginning and the end of each day. It's like writing a diary, sitting there milking the cows, but it's relaxing."

Michele Carrocia sews clothes. Her ancestors have been in Montana since 1836 and ranching the same area since 1880. "If women ranchers always had to have company around, we wouldn't have a West. There is no lonely. You don't rely on someone else or something else to entertain you. Everything has to come from within yourself." She adds, "I'd rather be outside riding, working cattle, than anyplace else in the world. It's a feeling of belonging; everything is right."

Three generations, from left: Sharon Lusko, Celeste Sellers,
and Nina Robinson, Fairview Ranch, Hanksville, Utah.

"We have not sufficiently been made to feel the presence of women in the history of the West.... The women who in their daily lives have built this distinctive culture have quietly been at this work for a very long time. They have always been here and it has always mattered. For those of us who love the West and make our lives in it, this news has the power of the best things that are saved for last."

THOMAS MCGUANE, IN THE FOREWORD TO "HARD TWIST"

Sandy Cook Rosenlund and sons. She was born in Nevada's Ruby Mountains where she and her husband are raising the next generation on their cattle ranch. "Town from here is about seventy

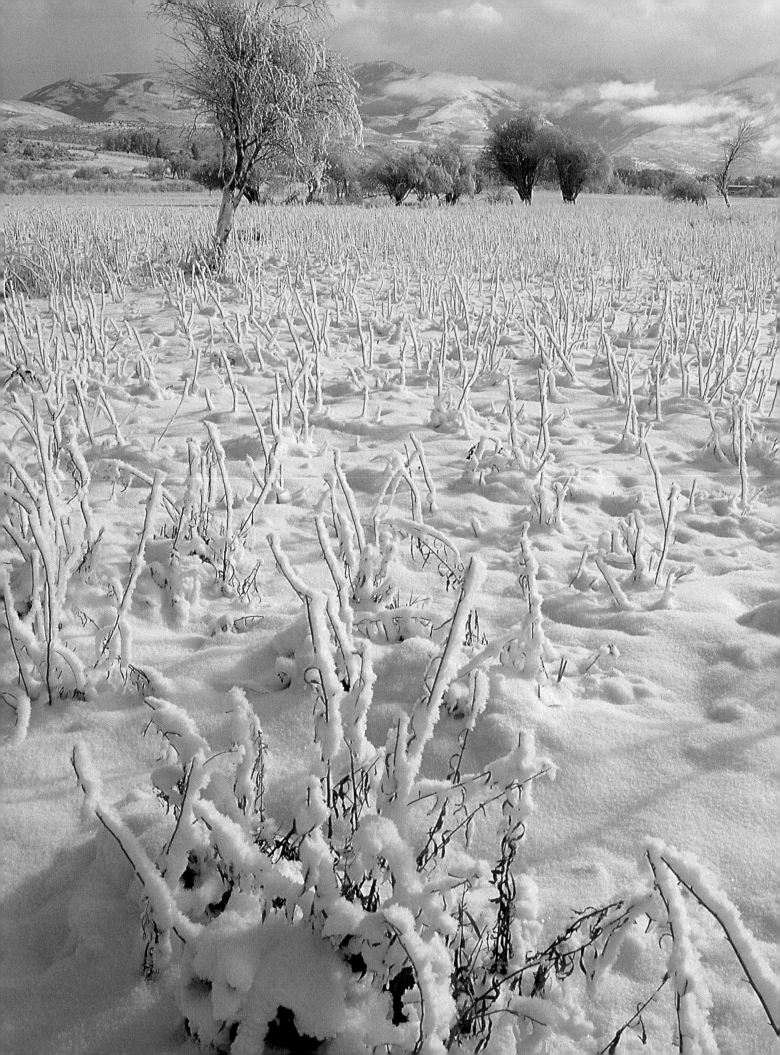

The White Season

The Paiute of northern Nevada call it "Pogo Nip." It means literally, "white death," and it can appear suddenly on a black night in depths of winter when all the trees and the grasses and anything left in the air will be stitched solid in killing white hoar frost. Cheyenne on the Great Plains had many words for winter and fearsome blasts of arctic blizzards screaming across the open grasses all the way from the arctic pole. It is a time exaggerated by some who have heard the most fearsome stories, but winter in the West always hides death as part of its tricks. Little children learn this from their Paiute parents. They are warned not to breathe deeply when Pogo Nip is in the air.

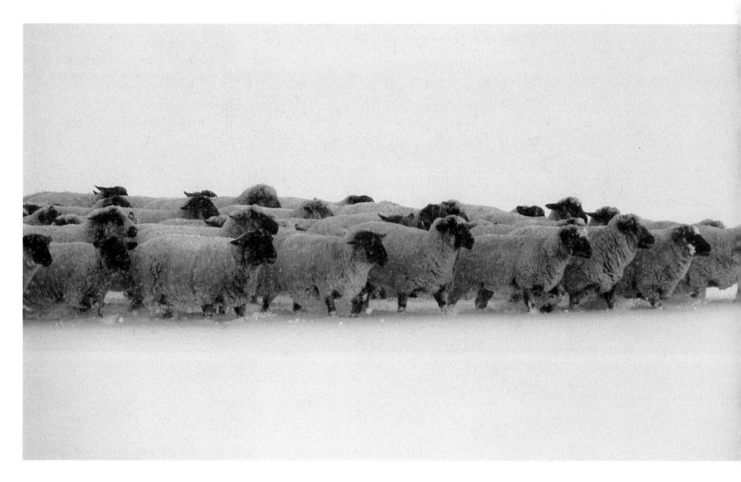

Lamoille pogonip, Elko County, Nevada.
© *Cynthia A. Delaney*

Heading for the home ranch, almost time for lambing.
© *Linda Dufurrena*

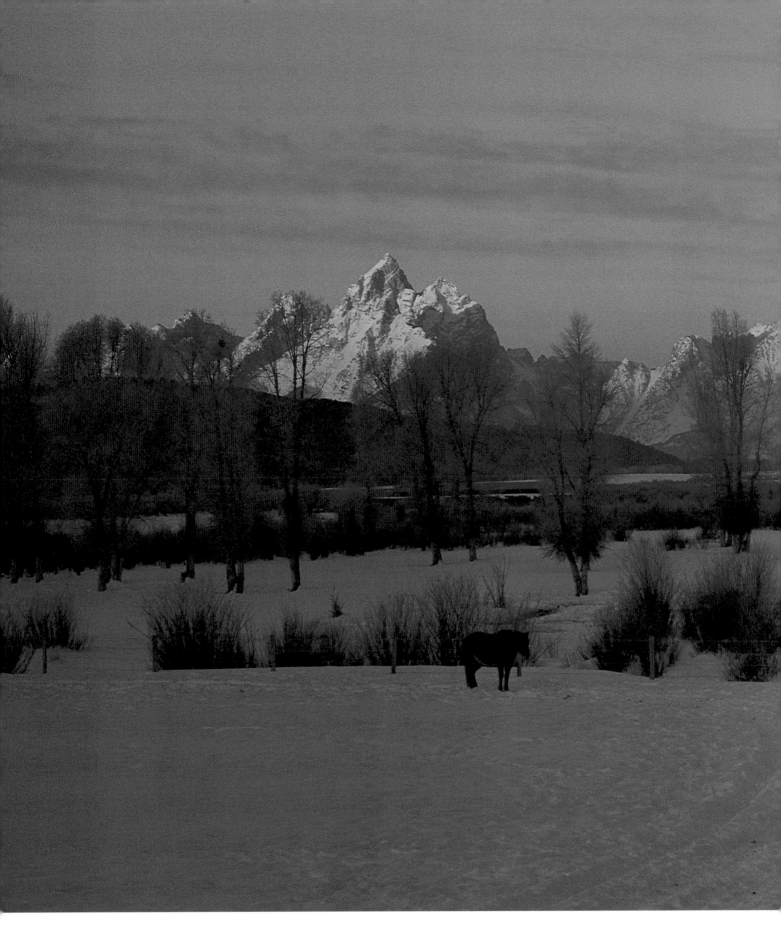

With the snow-covered Teton Range in the distance, this is what thirty-three degrees below zero at the Diamond Cross Ranch looks like on a biting cold January morning in northwestern Wyoming. © *Mary Steinbacher*

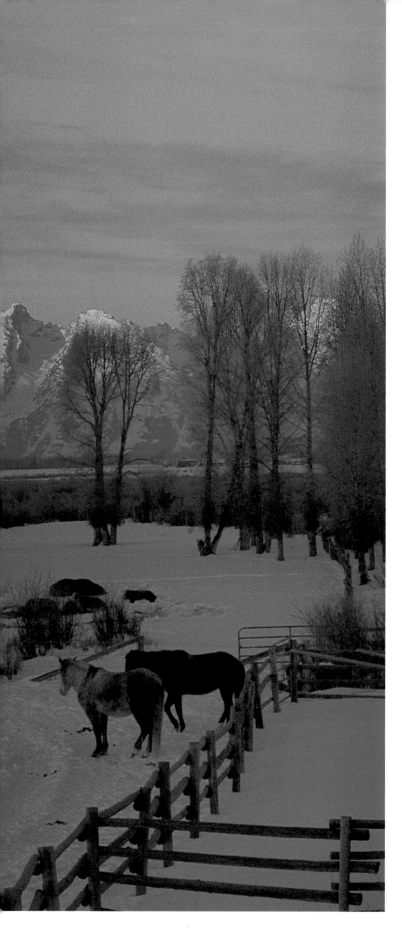

In the Rockies, winter is king. All else for life draping across thousands of miles from the spine of North America depends on that single season in the mountains. There, it is not often depicted in looping garlands and sleighs slipping along soft white trails. In the Rockies, winter comes serious and stays long, seldom routine or simply introduced, but more often demanding and frequently angry.

"My earliest memory is of knowing it was coming when my mother started stocking up all that Campbell's soup in the pantry to cover the times when we would be snowed in," says Todd Durham of Cameron, Montana.

Everybody seems to agree now that winters for the last half-century have not nearly been as severe. Todd's mother, living then in the same house he does now, remembers a period in the Madison Valley in the late 1940s when they were sealed from the world for a full month by the deep snows and relentless storms. He and his sister grew up in times delighted when they could tie their little runners on to the back of the bobsled and skim across the high drifts out to feed the cattle. And at night, the warm smell of the oil stove and the feel of dry socks on your feet seemed part of the enchantment.

Winters are no longer so severe, but they are at least regular, and with thinner crusts perhaps that break to frozen puddles, the season seems to last as long. As, indeed, it must, for what will follow in all the glory of the growing season will depend most on what is released from those mountains. It is another reason why spiritual and religious belief is strong among rural people. The winter helps teach them.

Snowstorm along Highway 395, Lake County, Oregon. This has been a vibrant logging and ranching community for more than a hundred years until the spotted owl controversy put loggers and mills out of business. Now anti-grazers are attacking the cattle and threatening to replace them with coffee shops. © *Carolyn Fox*

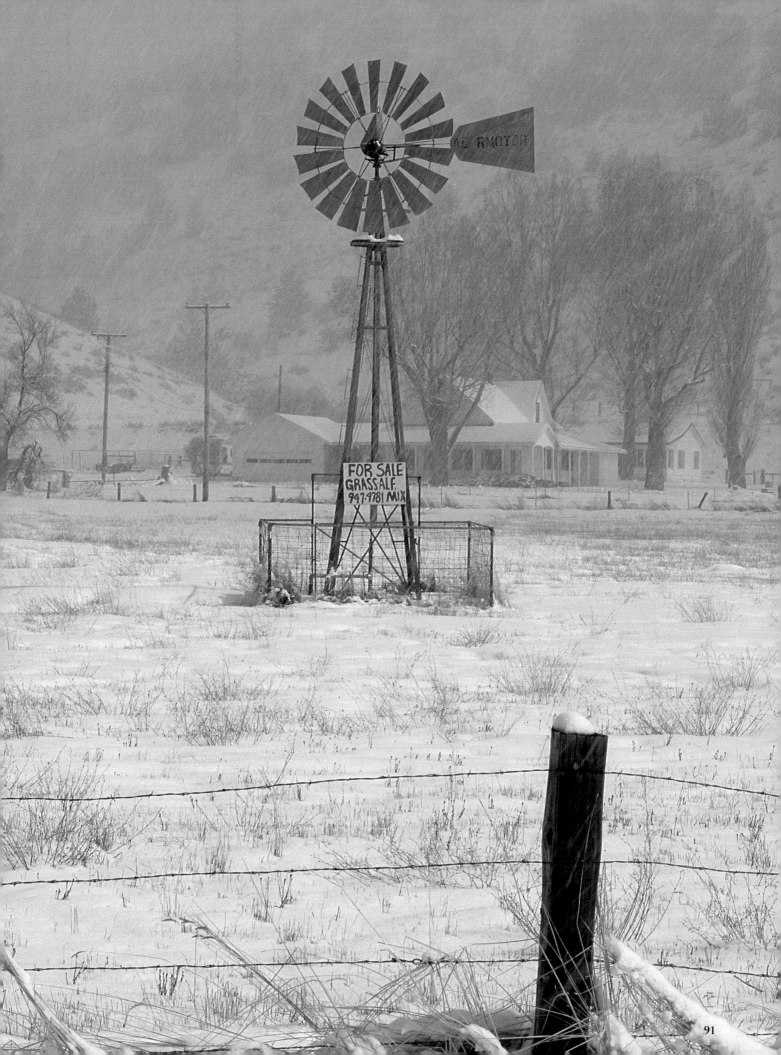

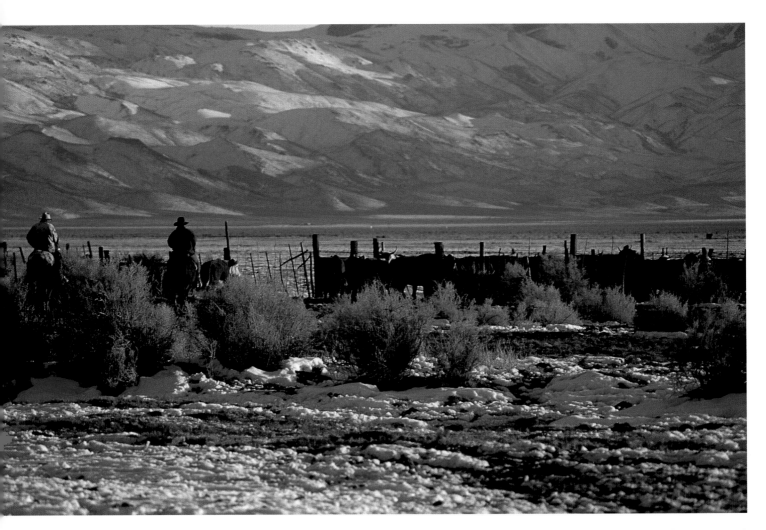

Barry Bradford and Tim Dufurrena check the herd at Bog Hot Ranch, northern Nevada. © *Linda Dufurrena*

Luis Velasco, cold and wet, ear-flapped and bundled, thinks of home in Mexico while he holds a Montana colt for branding. © *Guy de Galard*

White Days Gone By

By Eric Grant

It seemed colder now.

The sun had just risen and pierced the snowy valley. The cows gathered and waited around the watering hole, which had frozen over during the night.

Our pickup crawled through the snow and across the pasture. We stopped. John White picked up an axe and walked through the cows. Too cold to move far, they barely stepped aside to let him pass, their breath rising in the air. He chopped until the ice broke away. With each whack the hole became bigger. I could hear the water gurgling, splashing as he scooped up chunks of ice with his axe blade, using it like a shovel. By the time he quit, the watering hole was three feet wide.

The cows pressed in and began to drink. As cold as it was, it wouldn't be too long before the hole would

freeze up again. John chuckled about the winter and the hard work it required to care for cows on days like this. We would have to keep an eye on it this afternoon, he said, probably return before evening.

I looked at the frozen willows, the bare cottonwood trees and the snow-blanketed mountains around us. I thought about how winter's days cruelly tease old cows, many of which stood broadside to the sun to catch what warmth the sun could muster.

John wore a heavy, worn-out jacket that kept him warm. He pulled the flaps of his winter cap down over his ears. He had new gloves, a Christmas present from his daughter. The soft leather felt good. He pulled them off, reached for a can of snuff and stuffed a pinch into his mouth.

"Don't ever do this," he advised. "Take care of your teeth."

John was always like that. Simple actions. Simple advice. Simple example. He was a man of action, good

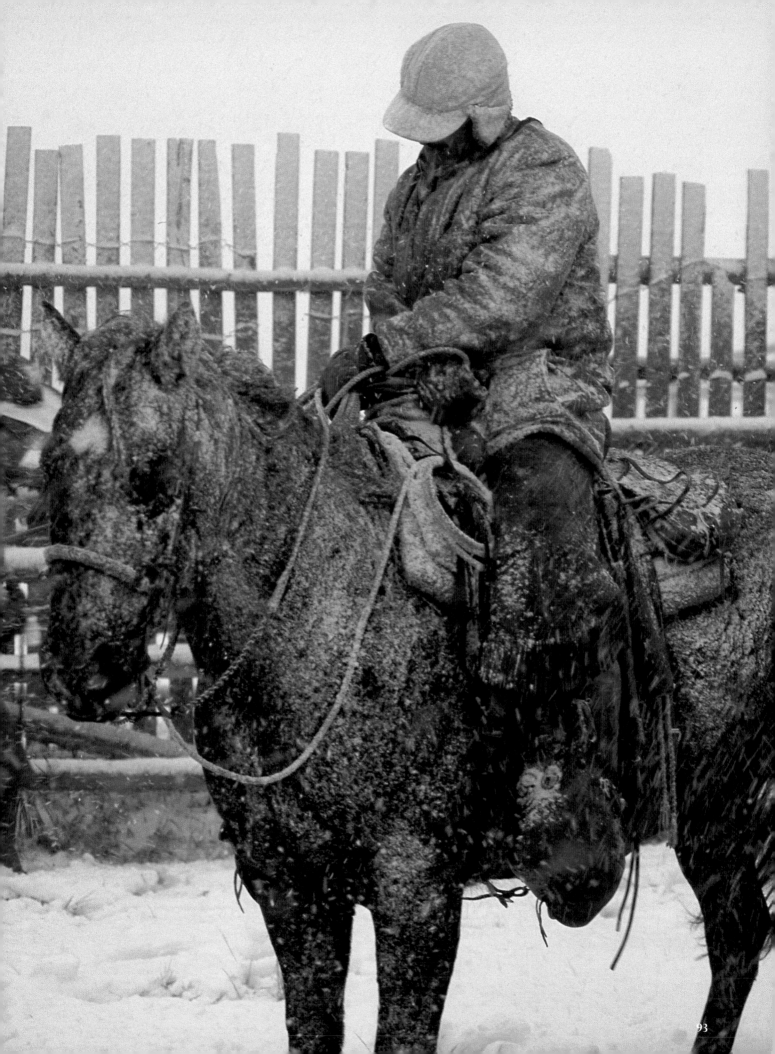

deeds and quiet accomplishment.

John came up the hard way, but kept his humor and happiness and direction intact. He gave peace of mind to those around him. Whatever the conditions, whatever the task, two things would always happen when John showed up: people would lighten up and laugh a little, and the work at hand would always get done.

No exceptions.

I met John in the early 1970s. I was eight or nine years old then. He was in his forties. He came to work for my grandpa. He was always on the job first, lined out and ready to go. I can't recall him ever missing a day. He and my grandpa became best friends, working side by side for seventeen years.

Next to his family, he loved most to ride. He was inspiring, plunging off the steepest hillsides to head off a

As the temperature drops, cowboys check the waters. They are using young colts that need to be ridden regularly no matter what the weather. © Barney Nelson

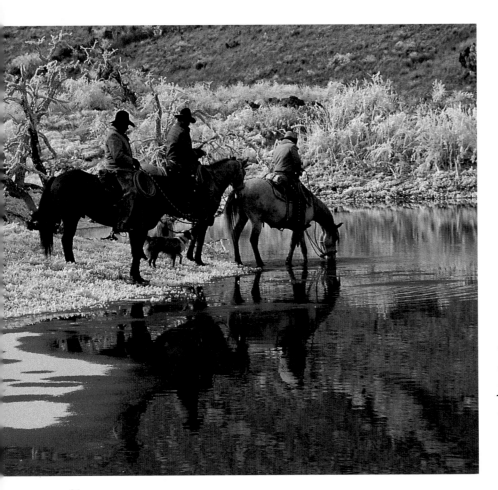

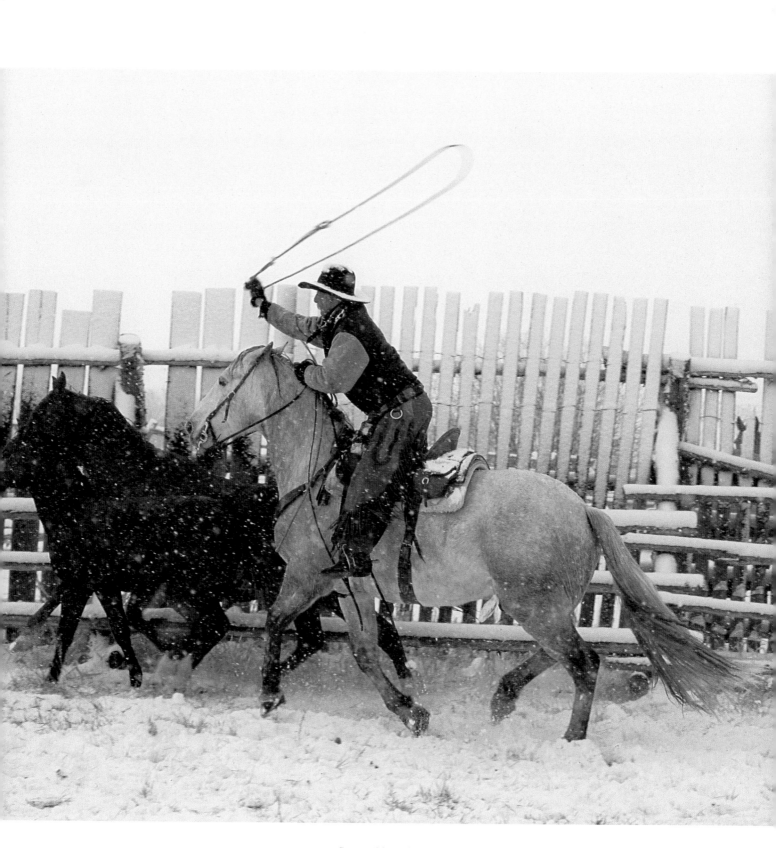

Steve Shroder ropes a colt for branding on a snowy day
at the Dragging Y Cattle Company, Dillon, Montana.
© Guy de Galard

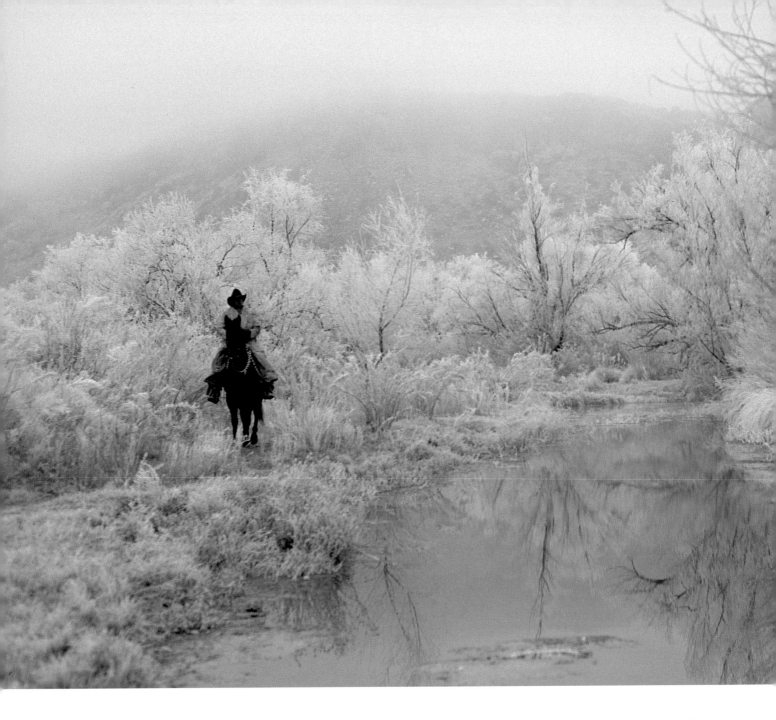

wayward cow, or crashing across an oak-brush ridge to stop a runaway calf. I can still see him mounted and at a dead run, riding hell-bent for Texas. He was absolutely fearless, but always had cautionary words for us kids after he trotted back.

He was gifted with tools, too. He had big, fumbly fingers, the kind that made us doubt that he could put back together the machinery he took apart. But things always ran better and more smoothly after John took his turn at them.

John grew up on the sagebrush range near Maybell, Colorado, just a few miles from nowhere, the kind of place most people drive through, if they go there at all. John was just a boy when his father died, but he dropped out of school to support his family. It was hardscrabble,

Great Depression living for such a young head of household. He hunted antelope to feed the family. They made it through, but it must have been tough.

Life didn't get any easier, either. John joined the army in the 1940s and fought Hitler's armies across Europe. He lugged a machine gun through mud and snow. It was cold there, too.

My cousins and I peppered him with questions about his war years. Looking back, I know now it made him uncomfortable, but he talked to us about it anyway. His stories began the same way, a stream of consciousness sweeping across France and Belgium. The wet summer. The snowy winter. The general who bumbled into his foxhole when the shelling began.

Then there were the death camps that he liberated,

David Alloway makes sure there's open water on Musquiz Creek for both cattle and wildlife to drink, Texas. © Barney Nelson

Cows in winter, looking for the feed truck. © Linda Dufurrena

Roger Peters, owner of the Dragging Y Cattle Company, ponders the weather. It's too wet for branding, so he postpones it for another day. © Guy de Galard

and John's recollections halted there. He didn't want to think about it anymore.

When he came home, he married Jean, raised a family, eked out a living. His highest aspirations were to raise a few cows or sheep, provide a good living, and find a little happiness in the West's open spaces. He wanted nothing of the outside world.

He and I lost contact when he left the ranch and entered the quiet years of his life.

When John White died suddenly, his family buried him in Clover Cemetery overlooking the pastures and hay fields where he spent so much of his life. The funeral was on a cold afternoon, with light snow and an occasional streak of filtered sunlight breaking through the clouds. Grandpa was happy they buried John nearby. It

was an appropriate place for him to rest.

"He was like a brother," Grandpa told me on the phone.

"He was like an uncle," I thought.

Grandpa had calves to feed before it got too dark and I had phone calls to make. I paused to look through the window. The sun was setting over the mountain. Snow completely blanketed the valley, and it would be very cold soon. Nighttime had just risen up from the valley floor.

No doubt there'd be plenty of ice to chop in the morning.

Eric Grant lives in Colorado.

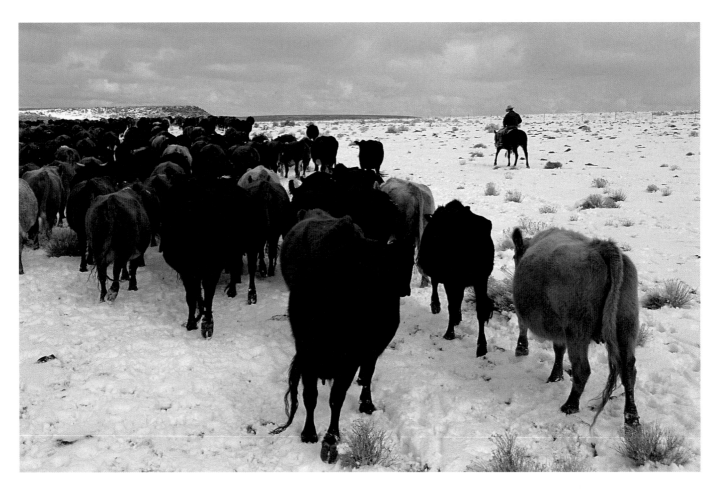

Two thousand mother cows are heading for the calving ground in Poverty Basin, a three-day walk from Paisley, Oregon. © Larry Turner

When hay tastes good, Jess Valley, California. © Duane McGarva

In February, at twenty-eight below zero, Jerome Young's frozen mustache is a sign of early morning work. He is feeding cattle and horses using a team of dappled gray percherons at the Diamond Cross Ranch in Moran, Wyoming. © Mary Steinbacher

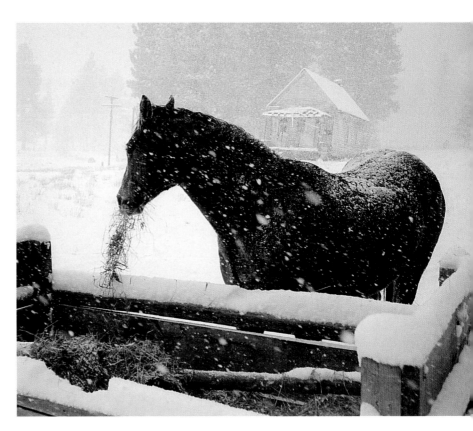

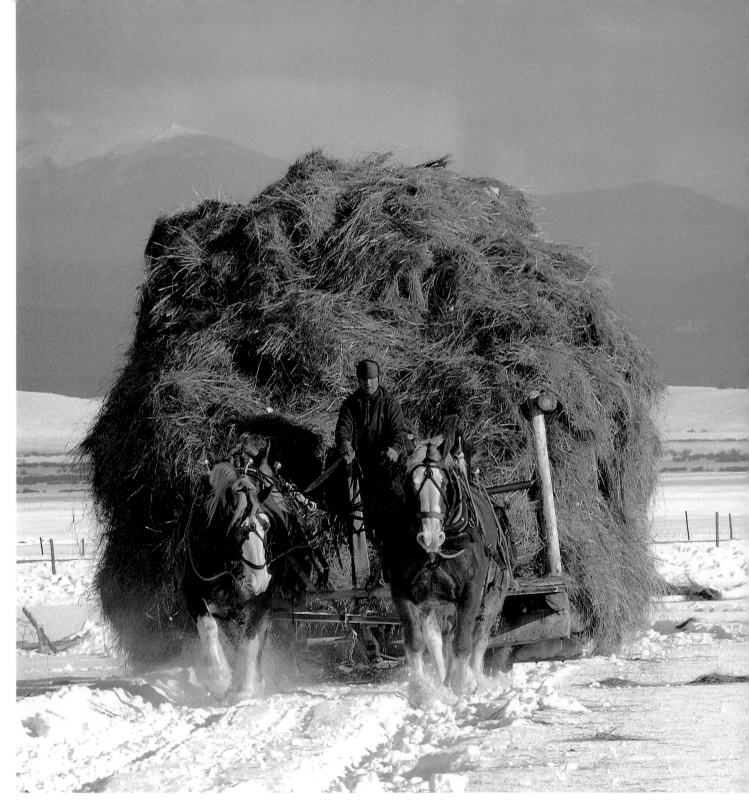

If you look closely you can see that Mark Raymond of the Ruby Ranch, Wisdom, Montana, is actually driving a four-horse hitch pulling close to 3,000 pounds of hay. The Big Hole Valley is one of few places in the West that still stacks hay using the Beaverslide and feeds loose hay. Raymond says, "I just can't imagine doing it any other way—it just wouldn't seem right." The Ruby Ranch, owned by the Dick Hirschy family, has two four-horse hitches working from early morning to afternoon seven days a week to feed the cattle. "These big horses take such pride in their work. If we get out of the sled path a little one way or the other, it is easy to get hung up in the soft snow. They put their hearts into pulling us out. When they get the job done, they prance and whistle and you can just tell they are proud of their accomplishment." © Cynthia Baldauf

Yearlings at the Dragging Y Cattle Company near Dillon, Montana at the end of November.
© *Guy de Galard*

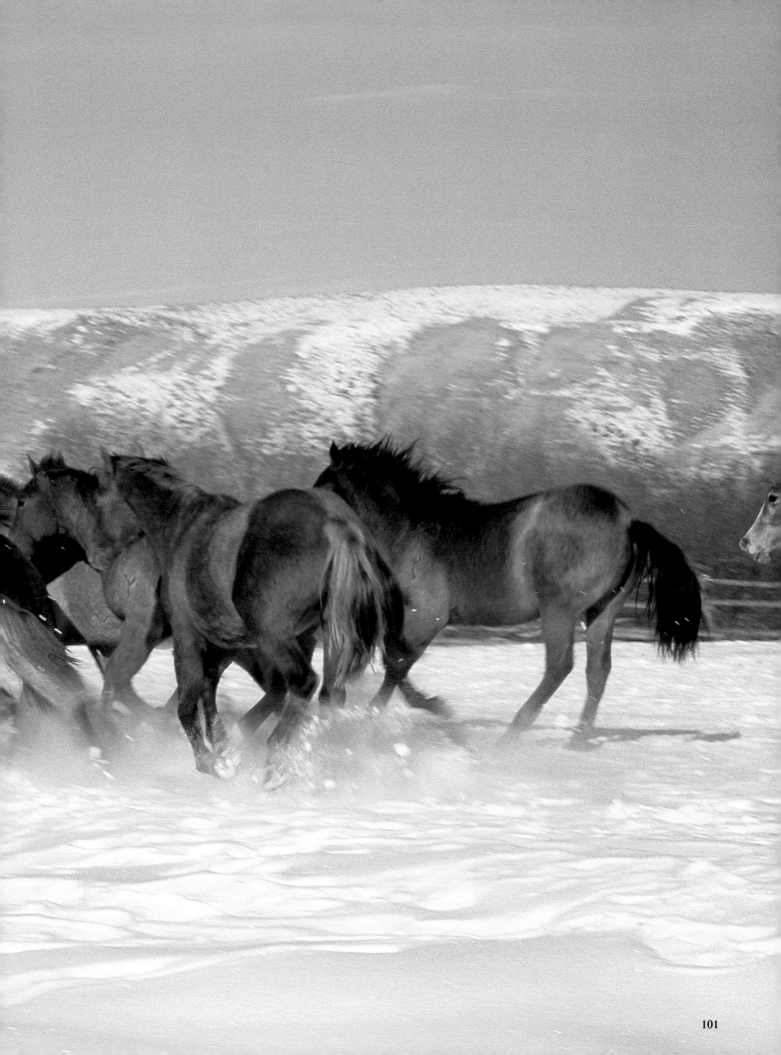

Harts Do Not Forget

Charles Marion Russell was born in Missouri. His father was secretary of the family-owned Parker-Russell Mining and Manufacturing and Charlie was expected to join his four brothers and two sisters in receiving a first-rate education and taking a role in the family business. But Charlie had another calling. He began sculpting and drawing before he started school, and his miserable grades indicated that his attention was not on his lessons. Charlie yearned toward the West and the cowboy life.

Bent's Fort in Colorado, the first settlement and trading post on the Santa Fe Trail, had been founded by his great-uncles William and Charles Bent with Ceran St. Vrain in 1833. A term at a New Jersey military academy failed to ignite a passion for book learning, so Charlie was finally allowed to take a trip to Montana. It was assumed that once the trip was over, he would come home and settle down. He was fifteen.

In 1880, the West was still wild. Custer's ill-considered battle was only three years past. Indians were regarded with suspicion and fear. Buffalo still roamed the plains. Charlie was home. To support himself, he took a job on a ranch, drawing and painting whenever he could. By 1887, Charlie's talent as an artist was beginning to be noticed, paintings exhibited and sold. In 1893, he traded cowboying for painting and "never sang to the horses and cattle again."

Charles M. Russell's bronzes and paintings earned him an enduring place as one of America's best-known and loved Western artists. A fortunate few saw Charlie through his letters and got to know his wit and humor, despite his whimsical spelling. As Charlie wrote to Tom Conway in 1917: "In the city men shake hands and call each other friends but it's the lonesome places that ties their harts together and harts do not forget."—*Barbara Wies*

May your days be better
Than the best your had
your wrinkles from laughs
not frowns
your nights bring dreams
that make you glad
and your joys be mountians
not mounds

I suppose this would be an easy throw
for aney of them skin string
Buckaroos

C. M. RUSSELL
GREAT FALLS, MONTANA

October 15
1919

Friend Con a few days
ago I got your letter and one a long time ago
which makes me owe you two I rote you one
since you went down to Cal but you never said
you got it

I'm glad you like that country and from what you
say its a good one . long ago I ust to hear
them senter fire long reatia Buckaroos tell
about Califonia rodaros but at this late day
I dident think thair was a cow in Cal that
wasent waring a bell . Poor old Montana is the
worst I ever seen in I'v been here forty snows
the reformers made her dry and the All mighty
throwed in with them and turned the water of
an now thair aint enough grass in the
hole state to winter a prarie dog
but if the misters could sell thair tumble weed
at a dollar a tun thair all millionairs
ist shure a bumper crop

I saw Jonny Rich not long ago he's running
a moovie show in Lewistown and dooing well
he says last winter when the flew hit his
town the Doctor advised him to take three

LETTER CONTINUES NEXT PAGE…

C. M. RUSSELL
GREAT FALLS, MONTANA

mouths full of booze a day to head off the
sickniss to make shure how much hes taking
Jonny measurs a month full which he says
is an eaven pint he followes the Doctors orders
to a hair and the Flew never tuched him said he
felt fine all the time but after about a month
of this treatment he got to seeing things that aint
in the natural history . one day he saw a Poler
Bear sitting on a hot stove waring a coon skin coat
and felt boots eating hot tommales

I went to the stampeed at Cangary this fall and it
was shure good saw a frew old timers some old
frends of yors

Charlie Furman said a long time ago he had a
horse that he was a frard of one day hes riding
this animal kinder carful with feet way out and
choking the horn when suddenly with out cause this
hoss starts playing peek a boo about the second

jump Charly is unloded among a crop of bolders
an he tells me hes numb all over and feels like every
bone hes got is broke in three places but when he starts

C. M. RUSSELL

GREAT FALLS, MONTANA

coming back to life & his hart gets big and all of a sudden he remembers he aint give Con Price no wedding present so next day he saddles a gentle horse and leads peek a boo over and presents him to you

Furaman says he dont see you for quit a while but when he dos meet you you say some things that I cant put in this letter and you said if ever you married again that he needent send no presents

I an sending you a couple of pictures of Jack Mame sent you som last winter in a Christmas pacage for Leslie but I guess you dident get them hes shure a fine boy and loves horses hes got a rocking horse and two stick horses an he rids the tail off the hole string I still have a caple of old Cynser and some times I talse him in the saddle with me and it shure tickles him we may come to leal this winter if we do we'l try and look you up I'r got a long range Cousin in that country maned Philips that is runing cows down thair some where well Con I'l close for this time

with best washes from the three of us to the three Prices your friend
C M Russell

CHARLIE RUSSELL'S ART AND LETTERS USED WITH PERMISSION
BY C. M. RUSSELL MUSEUM, GREAT FALLS, MONTANA.

The Ties That Bind

In farm and ranch country, folks tend to be doing the same things at the same time on their own places. There's a time to brand and trail cattle, a time to plant, and some time to irrigate before you take in the first crop. It's pretty much the same for everybody, dictated by the weather.

But if you want a real sense of these folks altogether, there's no more commonly understood and routinely appreciated circumstance than when a tractor flips over or when an arm is caught in a swather. Then, without being asked, they will all appear in their injured neighbor's field, using their labor and their machines to bring in his crop before going back to work on their own. It is simple custom all over the West, and it is common sense the way it should be defined everywhere. It's friends, family, neighbors.

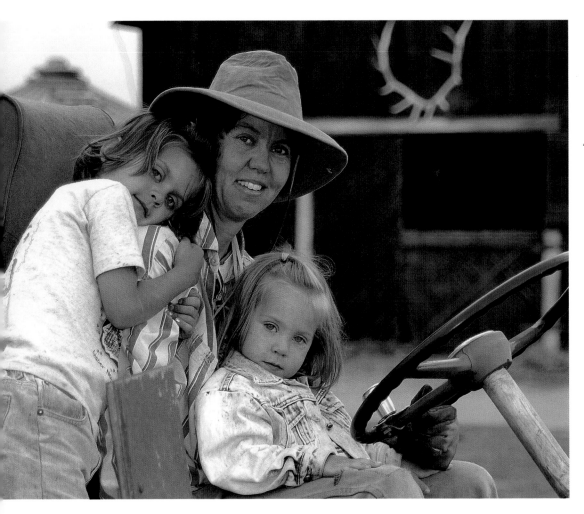

After spending a long day driving a buckrake, Lisa Peterson Nabity greets her daughters, Kelsi, six, and Amber, four. Putting up hay in giant loose stacks on the Harold Peterson Ranch in Jackson, Montana usually takes about three weeks.
© Cynthia Baldauf

While coiling ropes for his sons, Cole Butner walks with his young cowboys Tanner, left, and Shawn during a branding at the Klaren Cattle Company in Pinedale, Wyoming.
© Mary Steinbacher

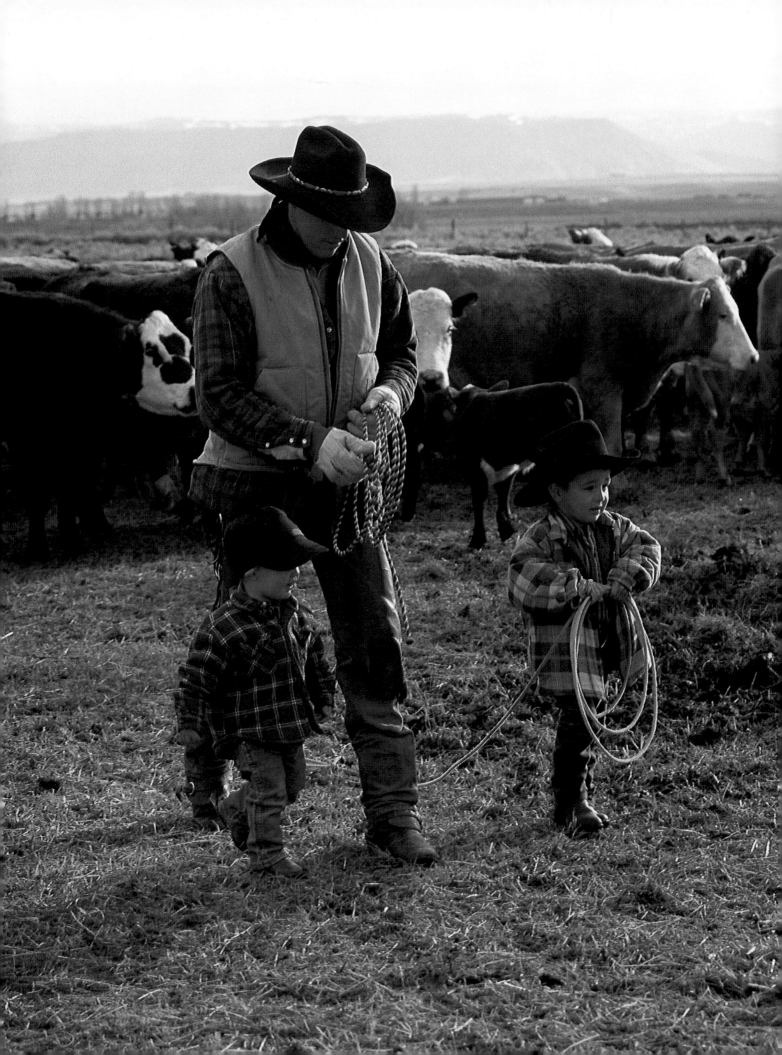

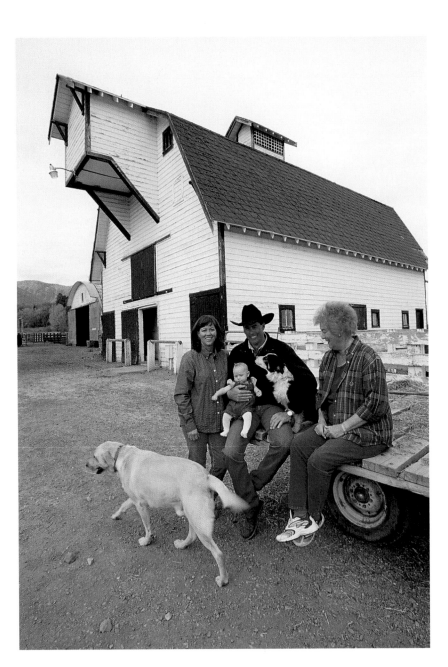

The Harrell family, Baker City, Oregon, left to right: Taz, Becky, baby Lexie, Bob, border collie Annie, mom and boss Edna Harrell.
© *Larry Turner*

Sierra Rose Hogan happy in the shade on a summer day, visiting a ranch in Nevada.
© *Cheryl Hogan*

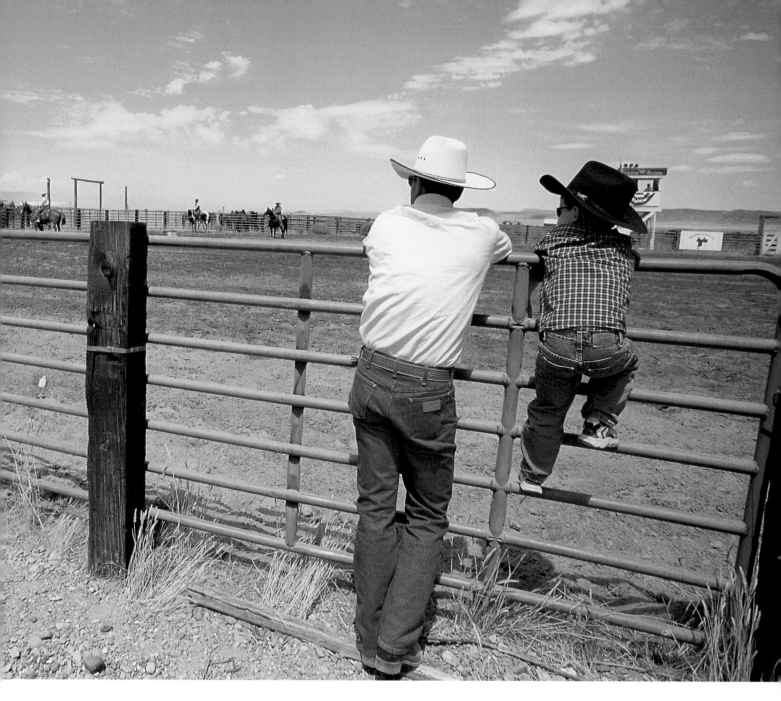

Father and son, waiting for the horse roping at the annual ZX Ranch Rodeo, Paisley, Oregon.
© Larry Turner

The annual Mutton Bustin' Contest is a real hit during the Silver State Stampede in Elko, Nevada. This little bucka-roo clings tightly to a running, bleating ewe.
© Cynthia A. Delaney

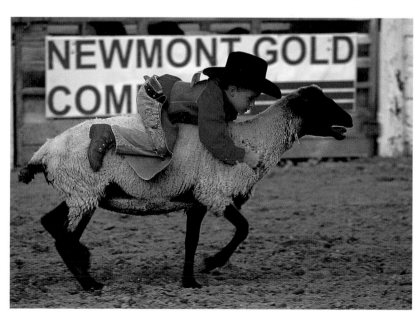

ZX Ranch Rodeo spectators and contestants, left to right: Cleve Anseth, saddle maker Len Babb and wife Sheila, rancher Martin Murphy, ZX ranch manager Dick Mecham, Tim Draper, Scott Grosskopf, and Don Boyd.
© Larry Turner

Carolyn and Tim Dufurrena get ready for a summer cattle gather at the Quinn River Ranch, Bilk Creek Mountains, Nevada.
© Linda Dufurrena

Bret Vickerman, left, and Len Babb out on the town on Saturday night, Paisley, Oregon, population two hundred.
© Larry Turner

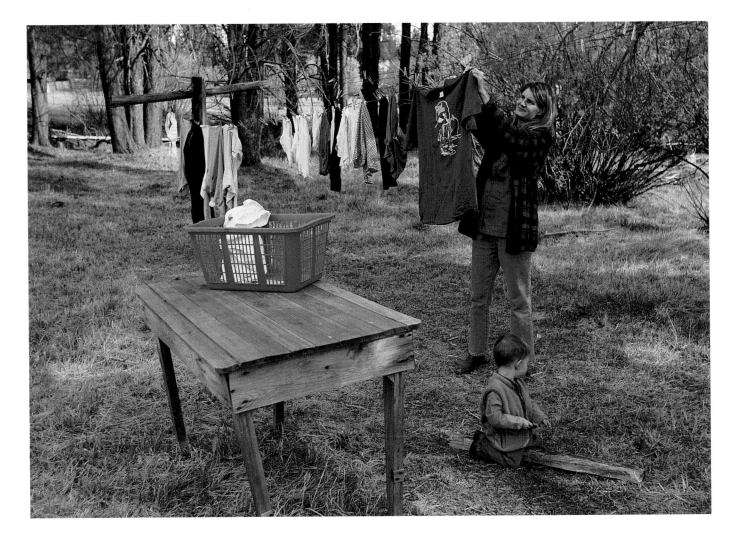

Becky Hatfield Hyde hangs clothes at Yamsi Ranch, Chiloquin, Oregon. Yamsi is the Klamath Indian word for "North Wind."
© Larry Turner

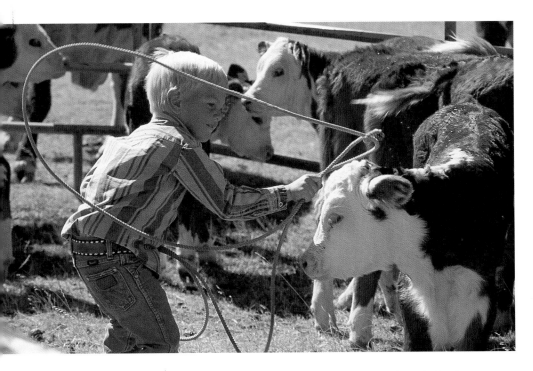

Three generations of ranch families gather on the Fitzgerald Ranch: the Fitzgeralds, Utleys and MacKenzies, Plush, Oregon.
© Larry Turner

Danny Reinhold on the Lone Tree Ranch near Sturgis, South Dakota.
© Guy de Galard

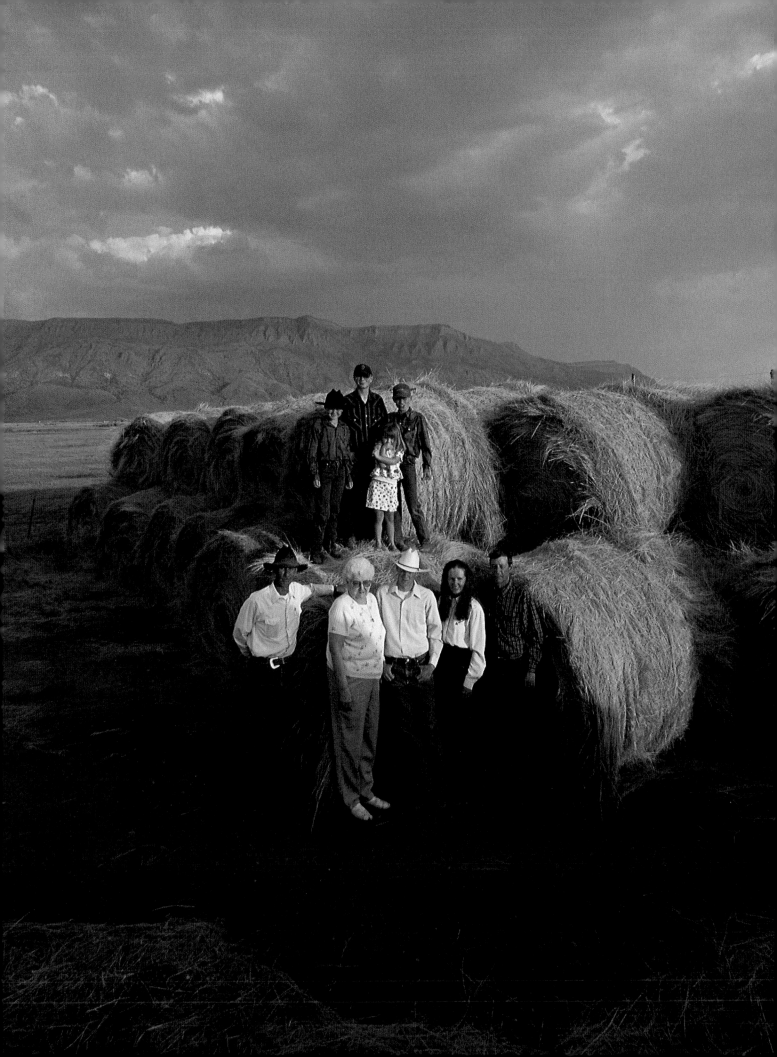

Pedro Antonio Marquez, Jr.,
continues a proud tradition.
© *Marquez family*

Eleven generations ago, a Marquez rode with Don

Juan de Oñate when he claimed Colorado's San Luis Valley for King Phillip II of
Spain in 1598. Here, where his grandfather's cattle grazed, Pedro Marquez and
his family have deep roots, drawing them back to this basin surrounded by
snow-covered peaks. Today, the hills surrounding the valley resound with the
joyful echoes of family and friends gathered for a branding. Maybe there is
another echo, one that goes back centuries to Pedro's Spanish ancestors.

Although they are all ranchers, Pedro is an architect, wife Sarah a teacher.
Older daughter Camila, seventeen, would like to study medicine. Anna, age ten,
plays the drums and dreams of being an interior decorator. At thirteen, son
Antonio is interested in ranching.

Grandparents Alcario and Celina recall when Pedro was about ten and spent
summers tending to irrigation and keeping fences fixed. "We were all raised to
help with the work," Pedro says. When told to do something, Pedro and his
cousins were expected to do it immediately to the best of their ability. No
whining or arguing allowed. "Being raised that way helped us all be successful."

—*Vess Quinlan*

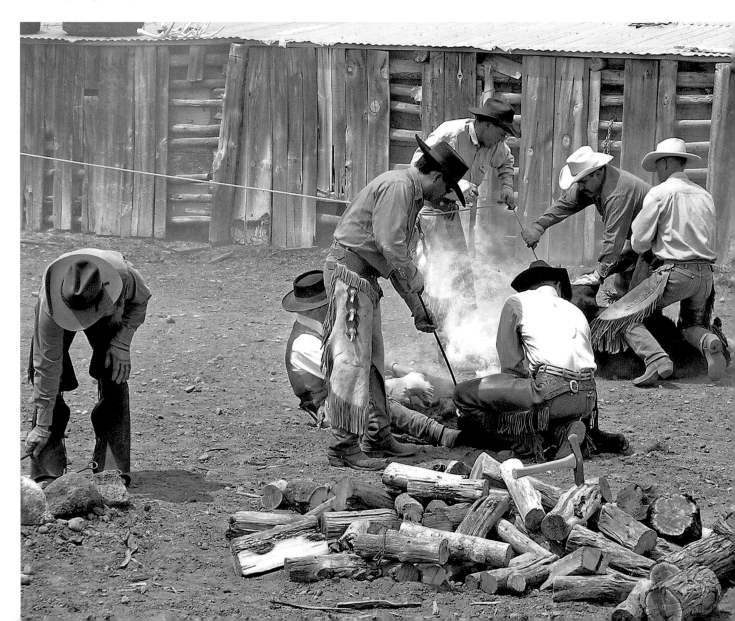

Camila with mother Sarah. © Hollis Officer

Pedro Marquez (in flat-brimmed hat) brands a calf with the help of friends and neighbors. © suzanattaos

Pedro and daughter Anna. © Marquez family

115

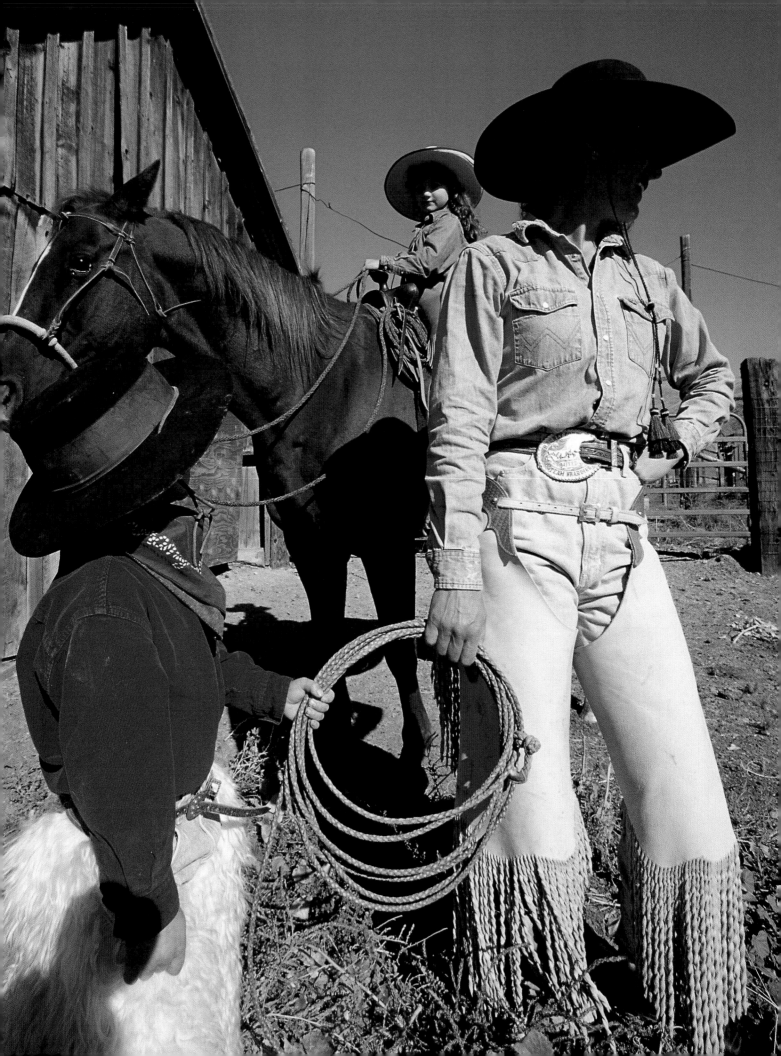

One of the West's finest ropers, Bret Vickerman, helps his daughter Alena blow bubbles. © Larry Turner

Rancher Martin Murphy, left, and ZX ranch manager Dick Mecham enjoy the Mosquito Festival in Paisley, Oregon. © Larry Turner

Linda Bentz with son Joseph and daughter Erika, Juntura, Oregon. © Larry Turner

Shelley and Charles Kerr raise alfalfa and cattle on the Kerr Ranch in Merrill, Oregon. The ranch is adjacent to the Lower Klamath National Waterfowl Refuge founded by Theodore Roosevelt, the first of its kind in the nation. The Kerrs share their crops with an enormous variety of birds and wildlife.
© *Larry Turner*

Young ranch girls like Carla Spencer and Sami Jones learn good work ethics early in life. Whether four year old, teenager or ninety year old, nobody's help is unwanted. There is always an important job to do.
© *Barney Nelson*

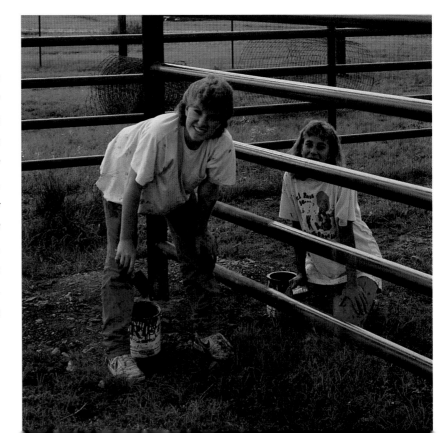

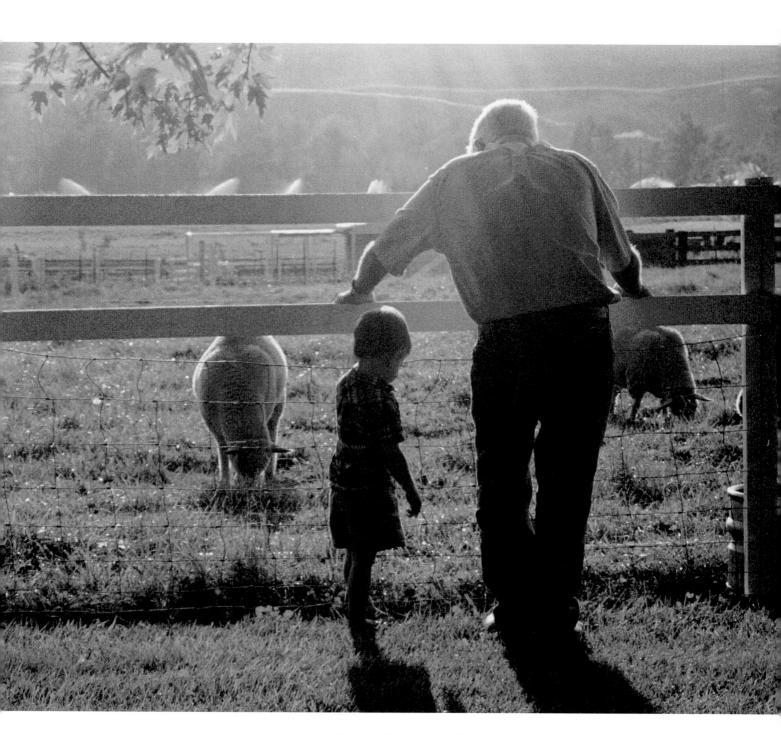

*Fence talk. Robert Rose and his
great-grandson Hayden Kennedy on
the Rose Ranch, Pendleton, Oregon.
© Amy Jellum*

Top Hand

At eighty-three, Georgie Sicking would be happy to be out punching cattle. She's been riding since she could sit up and be tied onto a saddle. Broke her first mustang at nine. Make no mistake, Georgie is a lady. And a cowboy. As cowboy, she earned the right to be called a "top hand," one of a rare breed who can do any of the tough jobs of cowboying and do it well. That included breaking broncs, mending fences, roping calves. Georgie says she knows how it feels to have a wild mustang fighting at the end of a rope. She knows how it feels to rock a baby. She says she's "raised kids and crops," but cowboying has always been her great ambition. She says that if there's any romance in western life it's in the stories cowboys tell, and she wanted to be a part of that life.

"I feel like I've lived, I haven't just existed," Georgie says. And in her poetry, she's told her own story,

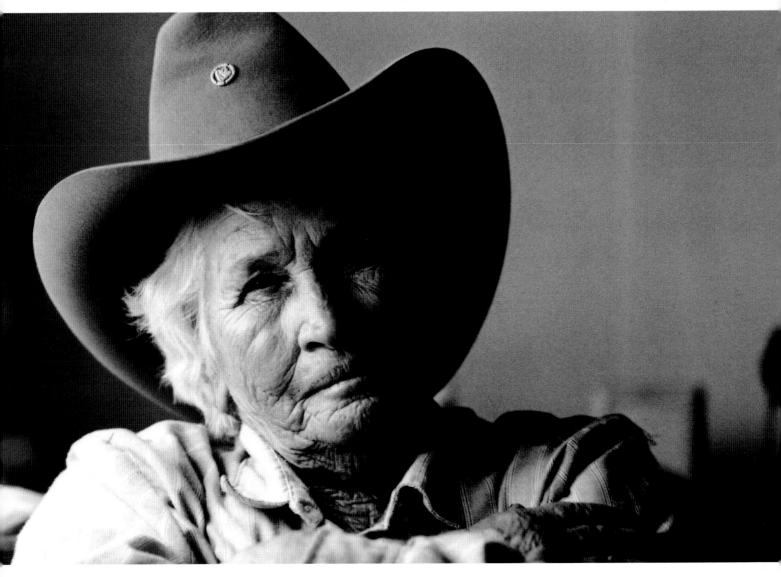

filled with romance and adventure, and seen from a uniquely feminine perspective. Georgie won the Gail Gardner Working Cowboy Poet Award from the Arizona Cowboy Poetry Gathering in Prescott and she was in the top ten in the Academy of Western Artists for Cowgirl Poets in 2003. She has a plaque from the Nevada Cattlemen's Association for "100,000 Miles on Horseback."—*Barbara Wies*

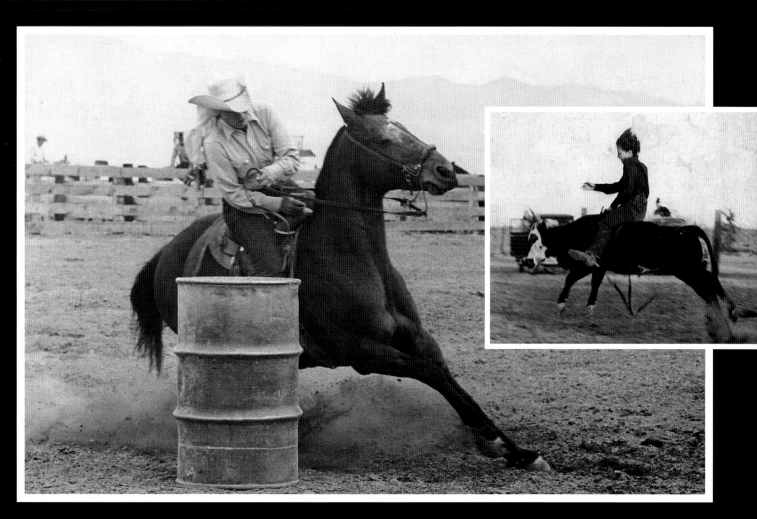

COUNTRY REWARDS BY GEORGIE SICKING

You ask me why I love this way
Of life, never thought much about it
I think that if I moved to town
I would die without it.

I just sort of get the feeling as I haul
Rocks and sand and sod
That regardless of the work I do
I'm working close to God.

The work is hard, the hours long
And pay it ain't that much
My face sunburned, my hands are rough
No time for fancy clothes and such.

When I see a newborn colt or calf
A reminder of God's creation
Or when my good dog works
For me without hesitation.

To greet the freshness of a country
Morning and hear a mourning dove's lonely call
The peace I feel down deep inside is a
Feeling best of all.

Georgie enjoys rodeo as much as she does ranching. She barrel raced and, as a kid, rode wild calves. BELOW: Georgie and Frank.

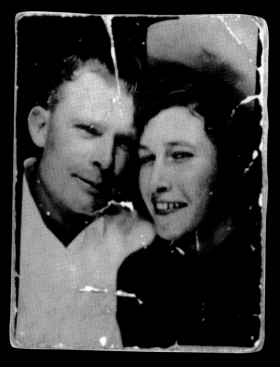

HISTORIC PHOTOS © GEORGIE SICKING
OPPOSITE PHOTO © REED BINGHAM

No Better Life

From the glory days of the silver boom on the Comstock to the days of internet communication, the Cliff brothers' family has nurtured Nevada. Perched on the slope of a lushly green valley are barns over one hundred years old. One was a sawmill in the days when the voracious Comstock took all the lumber it could find.

Things are quieter, now, if you don't count the jets flying overhead and the distant roar of the highway that bisects Washoe Valley. Donald and Norman Cliff are eighty-two and eighty. They remember watching the Reno-bound train from the window of their one-room school. They tell of riding their horses to Reno or Carson City for an evening of dancing. But most of all, the brothers' lives have been entwined with providing food for ever-hopeful prospectors, gun-toting editors, fist-ready politicians and other respectable citizens of what would become the state's capital.

An uncle of Samuel Cliff was already established in Nevada when the fourteen-year-old arrived from England in 1869. Seven years later, Samuel married. He had already bought his uncle's farm.

Samuel, his sons Alvin and Fred, and Alvin's sons Donald and Norman raised pigs, dairy cows, beef cattle and chickens. They had an apple orchard with its attendant beehives and gardens lush with vegetables and soft fruits. Samuel's wife Laura and Alvin's wife Alice used a water wheel powered by an artesian well to churn butter. Hams and bacon cured in the smokehouse. And all was shared with regular customers, some almost a day's buggy-journey distant.

One day in 1965, Alvin was return-

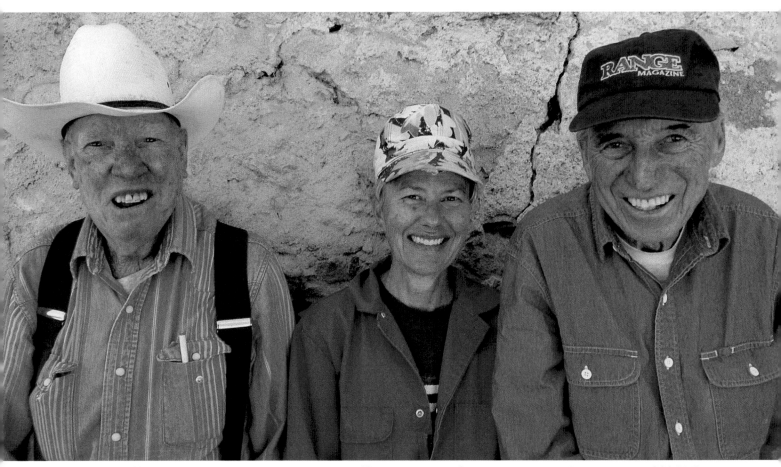

Norman Cliff, Shirley McDermott, and Donald Cliff, still chipper after branding cattle in summer 2004. They are standing in front of their 130-year-old barn in Washoe Valley, Nevada. © *C. J. Hadley*

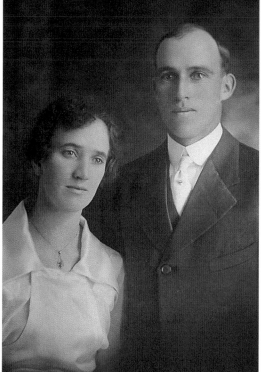

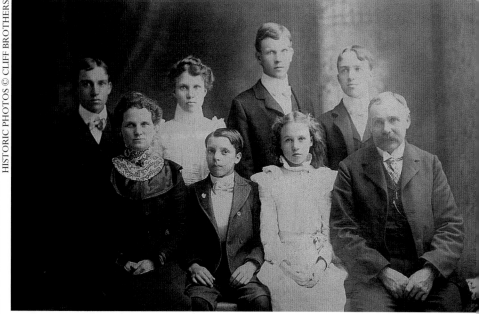

CLOCKWISE FROM TOP LEFT: Alice and Alvin's wedding photo, 1918.
■ *Front row: Laura Cliff, Fred and Bertha Cliff (twins), and Samuel Cliff. Back row: Alvin, Florence, Arthur and Frank Cliff.*
■ *Norman Cliff, Ted Kolster, Jack Cliff, Corrine Kolster, Donald Cliff.*
■ *Cliff Brothers Ranch in Washoe Valley, Nevada.*

ing from his regular delivery route, worried about his wife, Alice, who had been hospitalized with arthritis. An auto accident claimed his life. Older son Jack was married and living in Alaska. Daughter Joyce had a full-time job in town, so Shirley McDermott came to look after the household. Almost forty years later, she is still on the ranch.

When the Cliff brothers sold their small dairy in 1991, Shirley says: "It broke your heart. The few cows we kept were spooked, rattling around in the empty barn."

Beef cattle still range the meadows Donald has so carefully irrigated and Norman has harvested over the years. "The health of this area depends on the whole ranching community," Norman says. "You've got to have a good farmer to make a ranch look good. He's got to

make instant decisions about things like water."

For extra winter hay, the brothers have a ranch sixty-five miles away in Yerington. For the two weeks or so it takes to put up three loads of hay, they get up at two a.m. to drive there to bale hay while the dew is still on it.

Even so, Donald says, "I don't think there could be a better way of life."

—Barbara Wies

Enduring Heartland

Charles W. Guildner works in black and white, "preferably with an 8x10 camera." For thirteen years he has been chronicling the Midwest, photographing ranches and farms and the people who work there. He lives in Everett, Washington and returns to the Midwest each spring. He says, "I grew up in Nebraska so it's a wonderful time for me to get back to my roots."

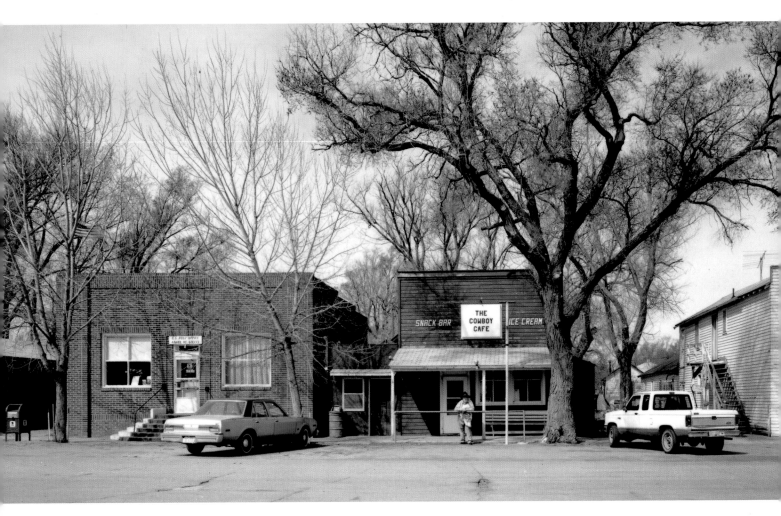

Main Street, Ashby, Nebraska, 1994. The Post Office, far left, was built in the 1950s; Charlie's Market, far right, dates from the 1930s; and the Cowboy Cafe, center, was built around 1900. © *Charles W. Guildner*

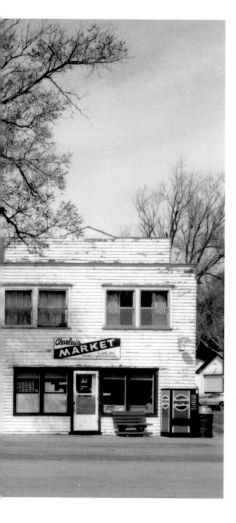

1948 Plymouth. © *Charles W. Guildner*

*Matthies Farm in Nebraska—neat, clean, well cared for and
suggesting the satisfaction of living the country life.
On this day, late morning, the air was crisp and clear with
the threat of an impending storm.* © *Charles W. Guildner*

CHARLES W. GUILDNER IS AN AWARD-WINNING PHOTOGRAPHER
FROM EVERETT, WASHINGTON. <CWGUILDNER@AOL.COM>

Mail Call

It might be photos from distant friends, a letter from a kid far from home, stuff from a mail-order catalog, or just the evening paper, dropped off by someone who knows your first name. Don't call it "snail mail." Out past the superhighways, mail is a warm handclasp. Letters are treasures. Books and magazines a welcome diversion at the end of a hard day. There's real joy in the whimsical mailboxes that greet the rural mail carrier.—*Barbara Wies*

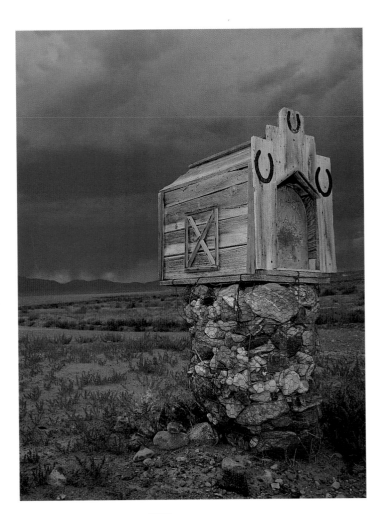

All photos © Larry Angier

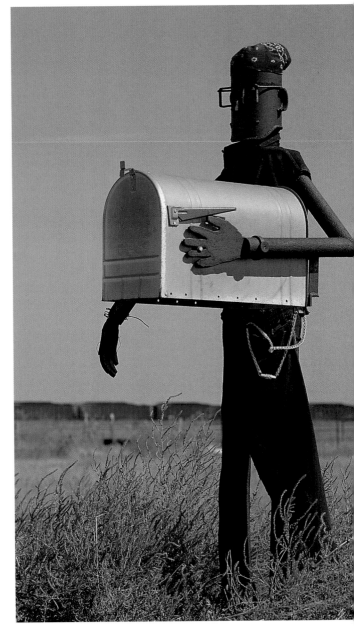

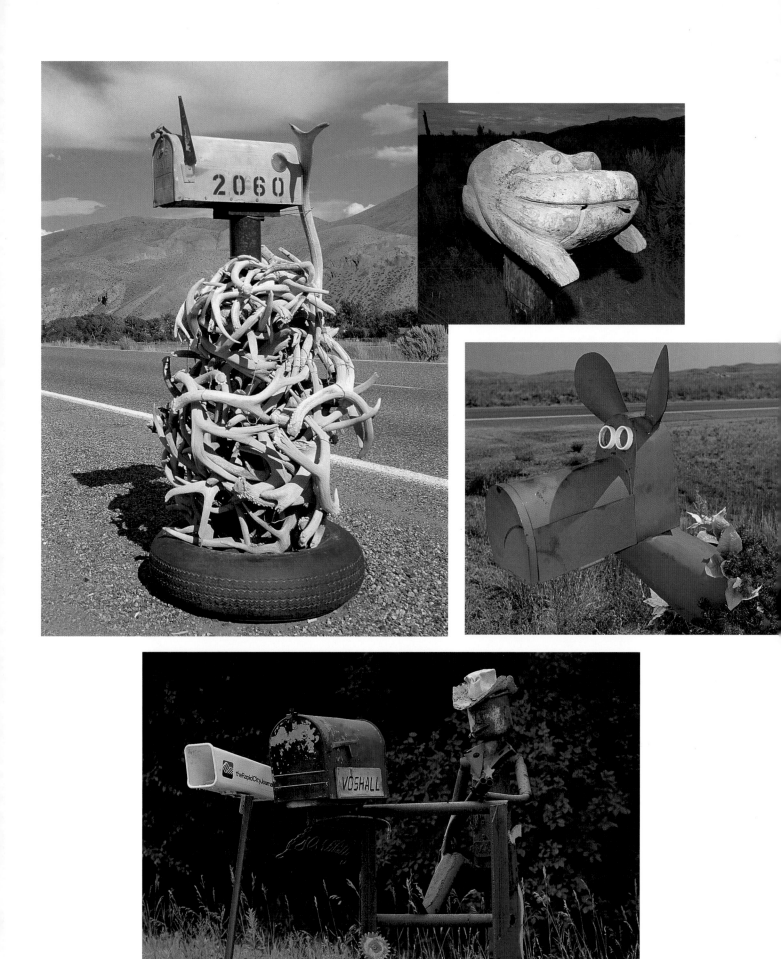

A misty sunset silhouettes winter oaks,
Jackson Valley west of Ione, California.
© *Larry Angier*

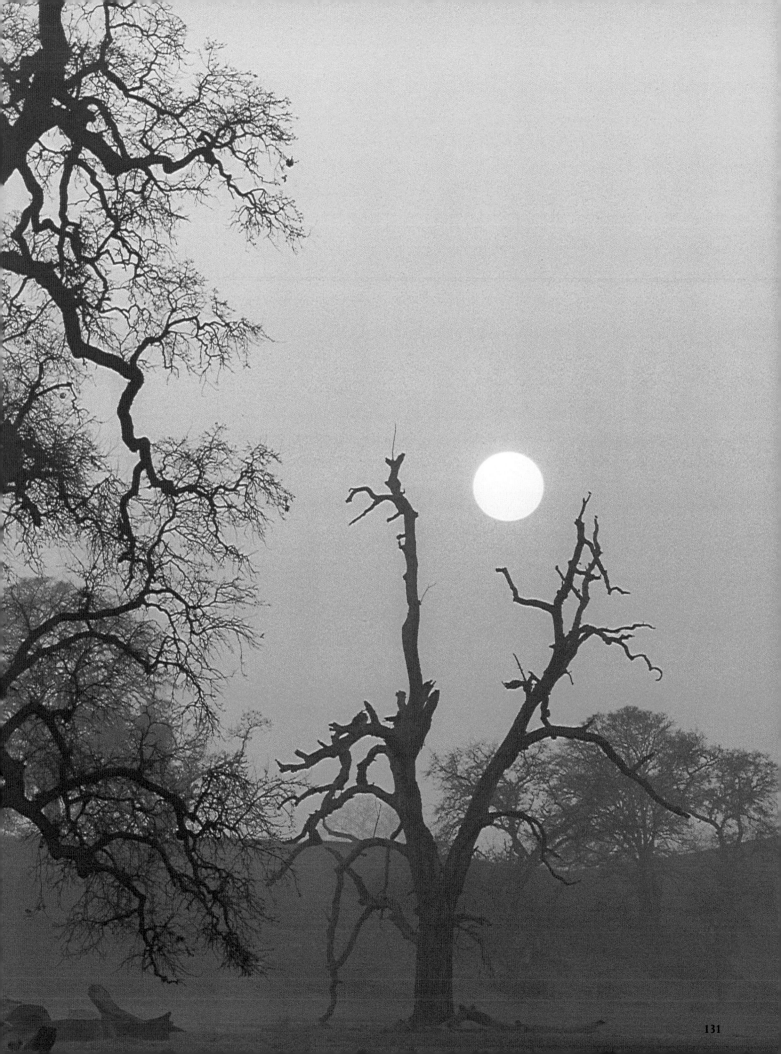

Way Back When

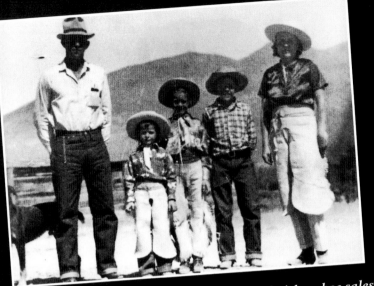

Their main source of fuel was sagebrush and dried cow pies. They ate a lot of jackrabbits and dandelions made good greens. Cows provided milk. Water was a problem. The Addingtons dug thirty-two wells, most shallow. "I was chipping with a pick and, bingo, we hit water. I yelled, 'Papa, we've got water.' I stood in the bucket and he winched me out." *VERNA WAGNER, BORN 1918, OREGON, SHOWN AT SIX WITH BIG SISTER LOLA AND BROTHER VIRGIL*

Their young mother took them and ran off with a shoe salesman to California somewhere around 1913. "There wasn't anything for us to do in San Francisco. We were so happy when my father came with two detectives to take us back to the ranch in Winnemucca. Kelly was always getting into trouble. One time he found a skunk in the chicken house and tried to get it out with a bat. The skunk won and we had to burn his clothes." *SIS BOYNTON, BORN 1906, NEVADA, SHOWN HERE, FROM LEFT, WES, TILLIE, JANE, JOHN, SIS*

For months, her father claimed she was a boy. She spent years proving she could work as hard and do as much as any man and anything a woman could do. At age eighty-eight she lost a finger dally roping. At ninety-one, she said, "I am just going to rope at home this year because I am getting too slow to rope at the neighbors." *HELEN HURNER, BORN 1908, CALIFORNIA*

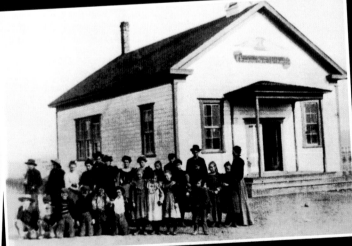

Dave Grove catches his almost ninety-nine-year-old face in the mirror and says, "You old bastard, you are looking pretty rough." But his neighbors disagree. "That cowboy's still dangerous in town!" *DAVE GROVE, BORN 1894, CALIFORNIA, SHOWN AT OVERTON SCHOOL, CEDARVILLE, CALIFORNIA (DAVE IS IN FRONT ROW, THIRD FROM LEFT IN STRIPED SHIRT)*

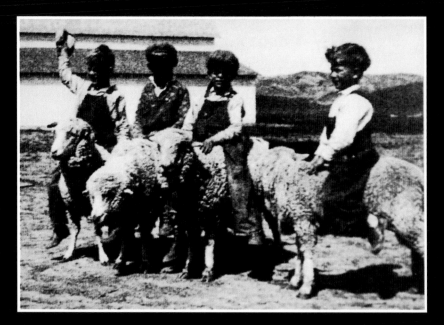

"Dad used to trade horses. He'd track them for two or three days and come back with a bunch. I think our life was pretty rough there—I went to bed hungry a lot of nights." AURY SMITH, BORN 1916, CALIFORNIA, SHOWN WITH HIS WIFE VIOLET

"I was bucked off a young horse while trailing cows in 1965. I thought my arm was broke. I got back on and rode 'im. Later, Doc said that was near impossible because my arm was fine, but my neck was broken." DON BURKE, BORN 1923, MONTANA, SHOWN (ON RIGHT) WITH HIS COUSINS RIDING SHEEP AT THE MISSOURI RIVER BOTTOM RANCH, 1930

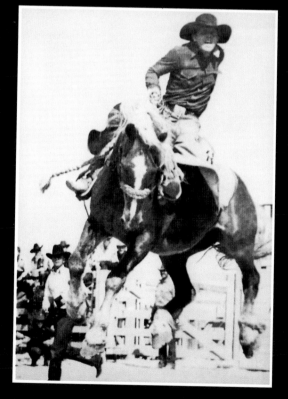

When asked by his dad to help a neighbor to trail cows, Torrey caught a horse and took off. "A hailstorm hit when we got to the Little Horn River. It was dark and I had to cross. In the middle the bottom dropped out and my horse and I were swimming in the dark. We made it across and followed the valley out west until I saw a light." It was the camp cook getting breakfast ready. He was given a new horse and they trailed the cattle home. "It was almost four days and fifty miles before I got home again." At the time Torrey was nine years old. TORREY JOHNSON, BORN 1916, MONTANA, SHOWN WITH HIS WIFE ADRIENNE

"Mustanging and chasing wild burros was the most exciting thing I ever done. I loved the competition and always went for the biggest and best I could find." LELAND ARIGONI, BORN 1911, NEVADA, SHOWN AT THE BARSTOW RODEO IN 1927

World War II vet Paul Rogers won a lottery for farmland in Tulelake Basin in 1947. "The wind was horrible. Dust storms all the time. We got used to it." The new farmers vigorously lobbied for improvements, like electricity. "There were hardships, but the good times overshadow the troubles. I had a farm. It changed my life." PAUL ROGERS, *BORN 1921,* CALIFORNIA, *SHOWN WITH WIFE* MABEL *AT THEIR WEDDING IN* OREGON

"We made moonshine, you bet. Camped out in the hills and had a still." The still held 350 gallons of mash, which took seven days to ferment and another day to make thirty gallons of moonshine. "You took a chance on how government agents would bother you, but they didn't take much interest." ROY SWAIN, BUCKAROO, *BORN 1905,* CALIFORNIA

Katie and Ernest, whose family had come to the Salmon River country in the 1880s, rode out the Depression in a three-room, sod-roofed dwelling that let in both wind and water. Katie raised chickens, hogs, bum lambs and a huge garden. She sold eggs, cream and the lambs. She canned meat, put up vegetables, scrimping and saving. By 1939, Katie had had enough of the old house, and had saved enough to do something about it. "I told Ern in April it was either a new house by Christmas or a divorce. I got my new house." KATIE MCFARLAND NEAL, BORN 1912, IDAHO, *SHOWN HERE WITH SISTER* MARY, *"DRESSED FOR FUN"*

Mary's husband died in a ranching accident in 1944. "We learned the hard way. I said we'll either go broke or make it. We were just starting up. It wasn't easy. My mother had a fit." MARY PORTERFIELD, BORN 1906, CALIFORNIA

"When I was about twelve, I had a team of four hitched to a corn binder. The farmyard turkey gobbler was being a pest so I gave him a kick. The team spooked and all took a wild ride right on through the barn, leaving the binder split in two and a hole in the barn door. To say the least, my dad was none too happy!" Even in his eighties, Howard continued to tame broncs. "No matter how tough the horses get, I can still break them."
HOWARD LEE, BORN 1913, MONTANA

"I got tired of walking on my knees dragging a sack and picking cotton," Johnny Thomas says, "so I decided to become a cowboy." He moved to New Mexico's mountains in '29 and tried trapping, "but hides were only bringing fifteen cents." He was living on cottontails, sardines, apples and frijoles. "Luckily I got a job herding 2,000 head of Angora goats. Made $15 a month, vittles and a cot." He started to rodeo and at Silver City, New Mexico, he gave a grandstand seat to a gal he didn't know. "Here was this gal cheering fer me like we was hitched. We met after the rodeo, had a romance by mail and got married after the 1934 El Paso, Texas, Wild West Show." JOHNNY THOMAS, BORN 1909, TEXAS, SHOWN HERE PLAYING "BILLY THE KID" IN THE '50s

"The challenges facing today's ranchers aren't much different from those I faced over the past hundred years. There's not much money in ranching and we have to live under a pretty tight belt, but you get to be your own boss and be out in the wide open. It doesn't get much better than that."
DON MCMILLAN, BORN 1902, MONTANA, STILL CHOPPING HIS OWN WOOD AT AGE NINETY-NINE

"I remember the sheep bells. For each one thousand sheep, ten wore bells while another ten to twelve were black. To make sure I had my whole flock together, once a day I'd try to get a count on the bells and blacks."
DONALD SIMMS, BORN 1920, OREGON, SHOWN HERE WITH HIS FATHER LYTLE HENRY SIMMS, IDLING AWAY THE DAY IN THEIR SUNDAY CLOTHES

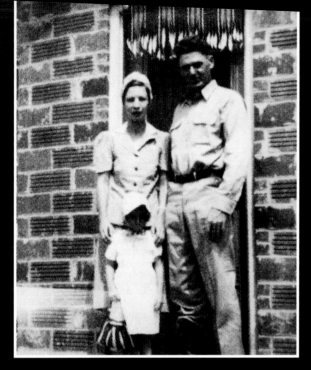

During the blizzard of '49, "Joe and I got stuck in town for three days and rode home cross-country, over fences completely covered by snow. Joe had to dig a tunnel to the front door. I'd put lard outside the window but it was so cold I couldn't get the window open and the snow covered the window so we couldn't get to it from the outside. It was hard to bake without lard, and frustrating because it was in plain sight." *WILMA SPENCER, BORN 1912, NEBRASKA, SHOWN WITH JOE AND DAUGHTER LYN, 1945*

During the Depression no one had a job, there was little money. Entertainment they made, with rodeos, barn dances, card parties and basket socials. "If somebody had a car and some gas, you went in style. But many times you rode long miles horseback to dance all night, then rode home again. Those high-backed saddles allowed us to doze off; the horse knew the way home." *HAROLD LOWMAN, BORN 1912, NORTH DAKOTA, SHOWN WITH WIFE ANN AND*

"I remember rising at 4:30 a.m. to milk cows and separate milk from the cream to sell to the dairies for butter and ice cream. It was a two-hour job, morning and evening." Much of the Gaspari land is paved now and it houses more people than animals. "Even so, when I see a horse, I think cows. In my mind I see cattle, open range, and pasture lands. I see a livelihood." *MELIO GASPARI, BORN 1911, NEVADA, SHOWN WITH FAMILY IN SILVER SPRINGS. MELIO IS SECOND FROM LEFT*

Pete's 100, his sisters are 102 and 97. Some say it's extraordinary genes, but it's probably their diet, "classic western, with plenty of beef, ham, bacon and eggs." Pete prides himself on having been the greatest hay stacker of his day, making "nice, square, straight up-and-down stacks." *PETE GERIG, RANCHER AND WRITER, BORN 1893, CALIFORNIA, SHOWN WITH GUY MOSS, FRANK GERIG, AND CHARLEY GERIG. PETE IS IN TOP HAT, THIRD FROM LEFT*

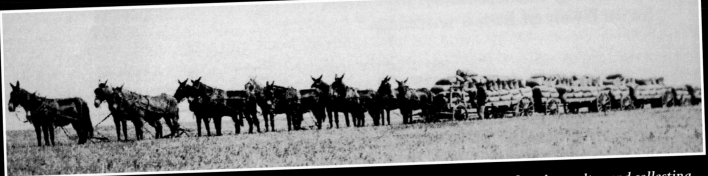

"We raised everything eaten except the flour and sugar. My chores included looking after the poultry and collecting eggs, and helping prepare the big meals that always included a good helping of meat, since everyone had to work so hard and there were always plenty of men who worked the mules." Helen cautions her great-grandchildren, "Never spend all your money. Always save some." HELEN MYERS MARSH, BORN 1911, CALIFORNIA

Annie Lou ran away from the city to become a rancher's wife. "It cost me three bucks to git married and it was worth every cent!" She and Andy never had time or money for a honeymoon. "We went to ranching sheep and goats. We were so poor I saved Andy's Bull Durham 'baccy sacks and thread from feed sacks to make a quilt for our bed." ANNIE LOU GOWENS WHITE, BORN 1909, TEXAS

"We care about this country and all the good neighbors who have helped us through the years, branding, shipping, hauling coal and chopping ice. The grass in the Badlands is some of the best in the world. The nutrients are perfect for making good-looking cows that turn into good beef steaks." SID CONNELL, BORN 1908, NORTH DAKOTA. PHOTO SHOWS OLIVE AND DAN CONNELL WITH CHILDREN SID, LESTER, NORA AND BLANCHE, CA. 1910

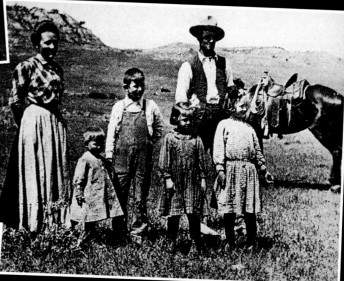

"You see a lot of crap in a hundred years but I have to say, every day since I was born has been a better day!" Collins rodeoed for a while. "When I made money I spent it on Cadillac cars, Ford pickups, cigars and good horses. I lived pretty fast; didn't fart around much. I still got a Cadillac car and a pickup truck but I had to give up the cigars and horses." COLLINS SAYNER, BORN 1899, TEXAS, SHOWN AS A TEENAGER, WITH A FRIEND

137

Cleo remembers the windmill pumping into a barrel, with a pipe leading from there to a reservoir. "I was small but I had a syrup bucket to dip in the barrel so I could water trees. One time I fell in; thought I was smart getting my own water. Mama made daddy understand I wasn't to reach down into that barrel any more." When she was older she knew what she wanted: "It was against my religion. I didn't want a farm; I wanted cattle and that was it."
CLEO FUCHS, BORN 1908, NEW MEXICO

After losing his mother when he was just six, Jerry worked for his room and board while trying to keep up with his studies. At nine, he was a water runner, and by age fourteen he was feeding forty head of cattle. He learned how to shoe horses at his dad's blacksmith's shop. "If a guy was willing to work he could get by." He loved rodeo and did gutsy trick riding, shown here. JERRY GETZ, BORN 1904, WASHINGTON

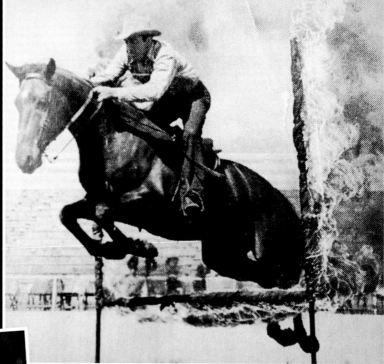

Their home consisted of two tents, one for sleeping, one for cooking, with a stove in each. The legs of the beds were placed in tin cans of water to discourage ants. "I'd get up early and take the sheep up into the hills, fill up water troughs for the rest of the livestock, cook breakfast and go to town to work, mostly at bookkeeping." She's happier now, not using a washboard.
AUDRA BRENNAN, BORN 1909, OREGON

If at sixteen your daddy pushed cattle on one of the last Texas to Kansas Goodnight-Loving trail drives, it'd be natural to follow his path. So Wags started early, at ten washing dishes and toting firewood for a ranch cook. At

eleven, he was promoted to horse wrangler for fifty cents a day. "I thought I'd never see another poor day." At one camp when he was older, his camp was so remote he recalls one stretch where he didn't see another soul for ninety-seven days.
ALVIN "WAGS" WAGNER, BORN 1913, ARIZONA

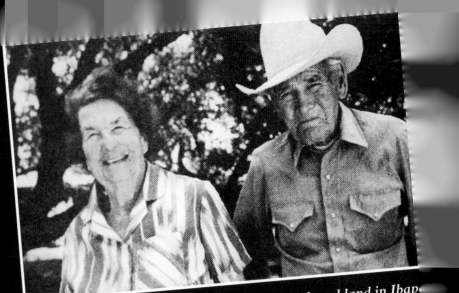

"...went to town for supplies he drove the wagon and team to Roswell. Took him a week to make the trip."
DOROTHY EPPS, BORN 1913, NEW MEXICO

When Jay and Leatha Hicks started out, agricultural land in Ibap[...] Valley cost $7 an acre and the principal form of transportation was the horse. "Luckily there were a lot of them around. Wild mustangs. Leatha would spy a bunch and I'd stick my old horse and go one way and Leatha would go another, running 'em toward me. I'd take my pick, maybe rope one and give it to her, then go and get another one. We'd break 'em to ride, trade 'em for a sack of wheat or sack of pota toes—anything." Jay also remembers prohibition, "when every sprin[...] included a still and the open range reeked of sour mash."
JAY HICKS, BORN 1910, UTAH, WITH WIFE LEATHA

His grandfather was full-blood Comanche. "He was proud of his heritage but didn't want to be given anything. He wanted to work for a living on his own farm and ranch." Buck won a football scholarship and earned a soil science degree at Cameron University. He worked for USDA and when he retired went back to farming and ranching. "None of that vegetarian stuff for me. Just give me some good beef."
BUCK CLEMENTS, BORN 1918, OKLAHOMA

His father trailed a herd of 7,000 cattle from Kerrville, Texas to southern New Mexico in 1882. His mother walked behind a covered wagon from Fort Worth, Texas, to Hope, New Mexico around 1890. And Edsil's as tough as they were. "I wore out three saddles in thirty-six years on this ranch. We worked it a horseback. Coyotes were thicker than jackrabbits. We had to fight 'em day and night. In a year's time coyotes killed over 500 lambs." Edsil's still going daylight to dark. "I gotta cut that beef out," he chuckles. "Why a 97-year-old fellow up the river just died and he ate it everyday. No doubt that's what killed him!"
EDSIL RUNYON, BORN 1918, NEW MEXICO

Cattleman Ty Holland enjoys the
fall colors in Grapevine Canyon, Texas.
© *Barney Nelson*

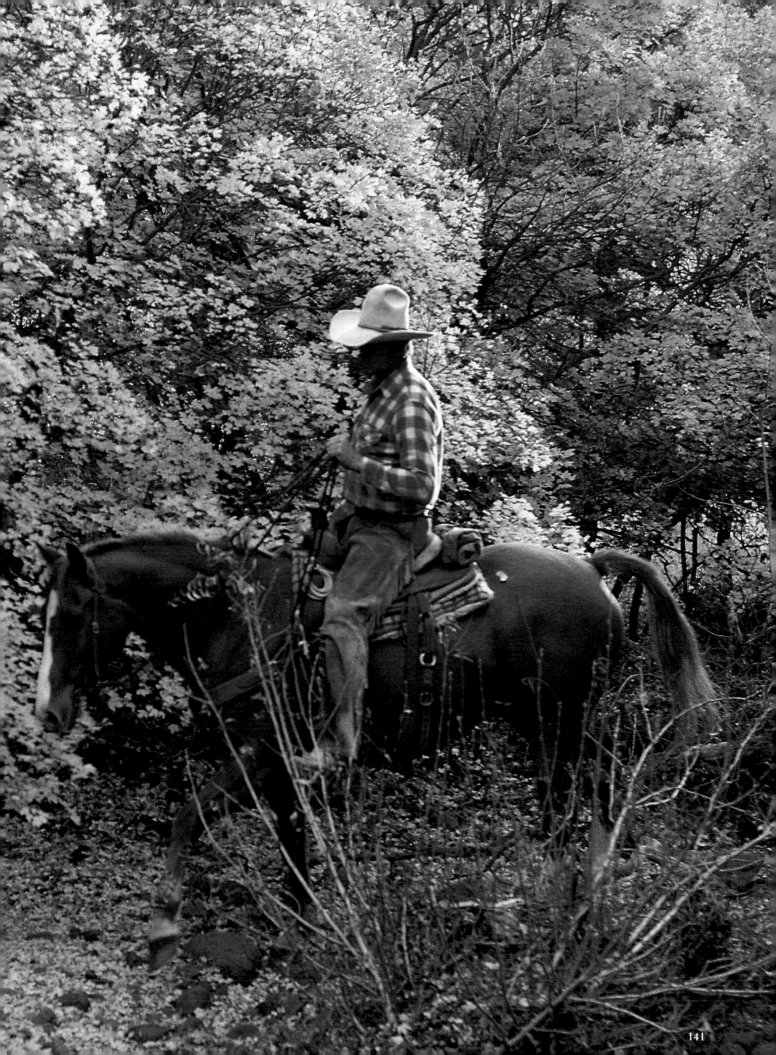

Inspired by Cowboys

For William Matthews, cowboys are the closest thing he's found to people who are truly self-sufficient. He devoted a decade to portraying working cowboys from the ranches of the Great Basin. This internationally acclaimed watercolorist's work can be seen at <www.williammatthewsgallery.com>.

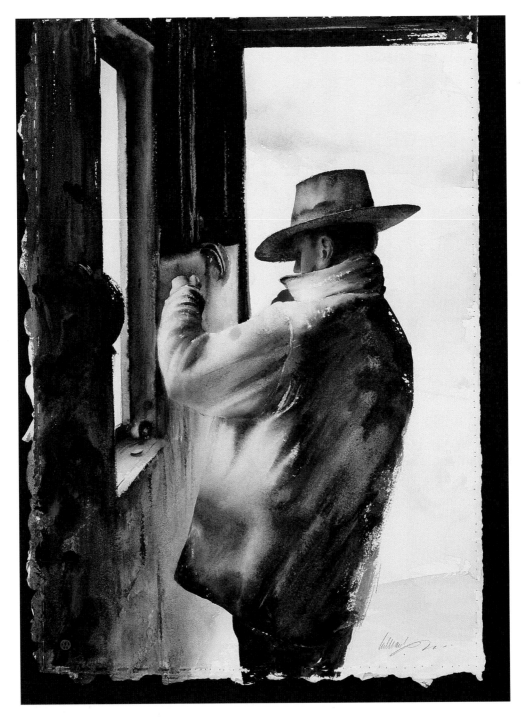

"Schutte in Charge." Watercolor, 30-1/2"x21". Private Collection.

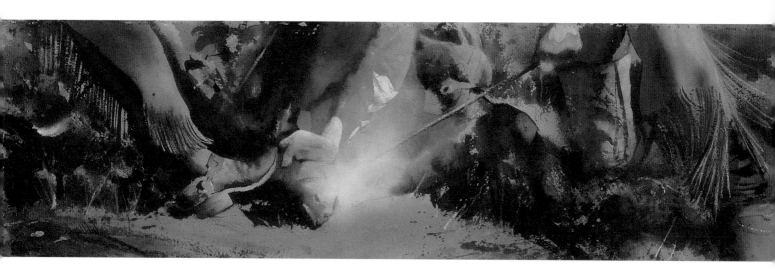

"Montana Boys." Watercolor, 11-3/4"x45". Private Collection.

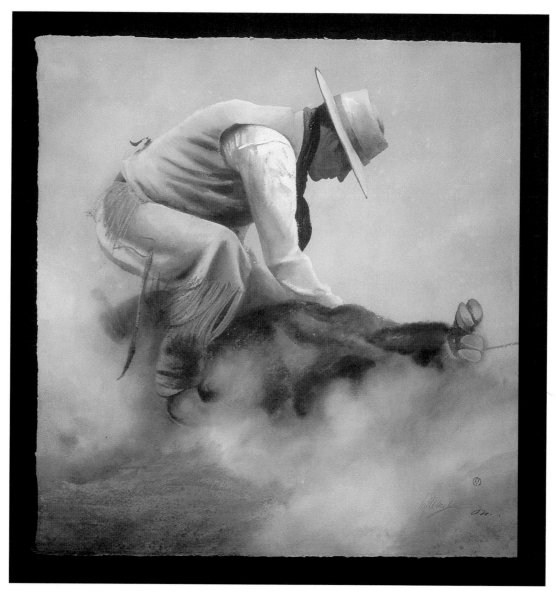

"Nevada Silt." Watercolor, 29"x29". Private Collection.

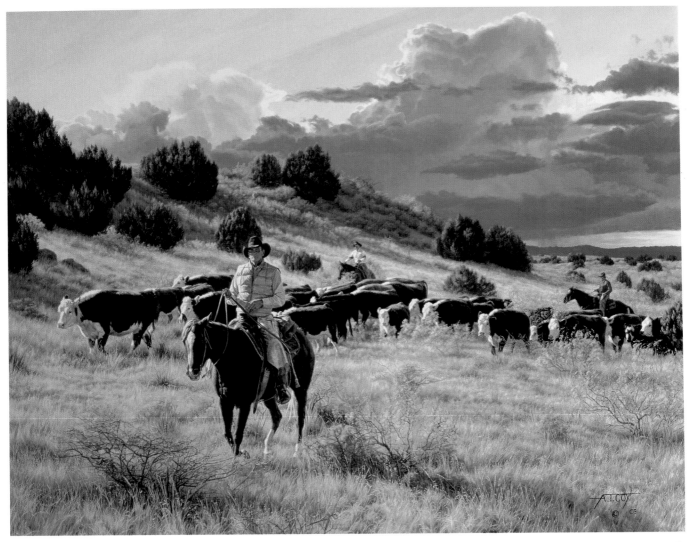

"On to Better Pastures." Oil. 22"x30".

Tim Cox

"On to Better Pastures" shows New Mexico Cattle Growers' President Phil Bidegain's family, owners of the T-4 Ranch, herding cattle on land they've owned for more than a hundred years. The painting won the Prix de West Award from the National Academy of Western Art. The artist, who trains cutting horses, says his paintings stress the values of hard work, integrity and family. <www.timcox.com>

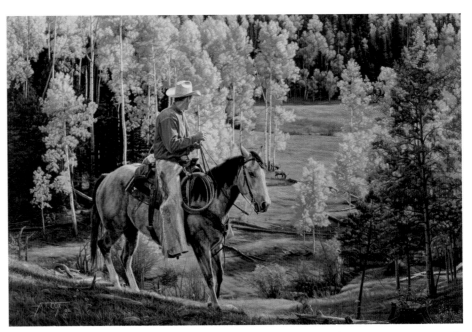

"Land of the Free." Oil, 16.5"x24".

Jack Swanson

is known and revered for his meticulous accuracy of horses and horsemanship. He trained with one of the last old-time vaqueros, raises horses, has a stall inside his studio, and a round corral right outside. As well as his paintings, Swanson's bronzes have won wide acclaim. "When you ride alone and quiet, you run into a lot of things no one else sees."

"Working the Herd—Cutting Out Bulls." Oil, 66"x36" (detail).

"6:30 a.m. on the Desert." Oil, 26"x42".

WILD

If they really meant to kill each other, one of them would surely have moved more quickly by now, but these few moments found them locked eye to eye, the intense gaze of the man finding a strange understanding in the reptile's equal stare. The buzz from his tail that had frozen the man in his step slowed to a rattle as the diamondback coiled in reverse, never taking its eyes from the man as it backed into the brush and disappeared.

The experience of wildlife in the West is only seldom expressed in a trophy. A rancher's livestock are not meant to conquer pristine land. At the worst, they might leave it bare for a time, desperate for life. But the real loser then would be the rancher himself.

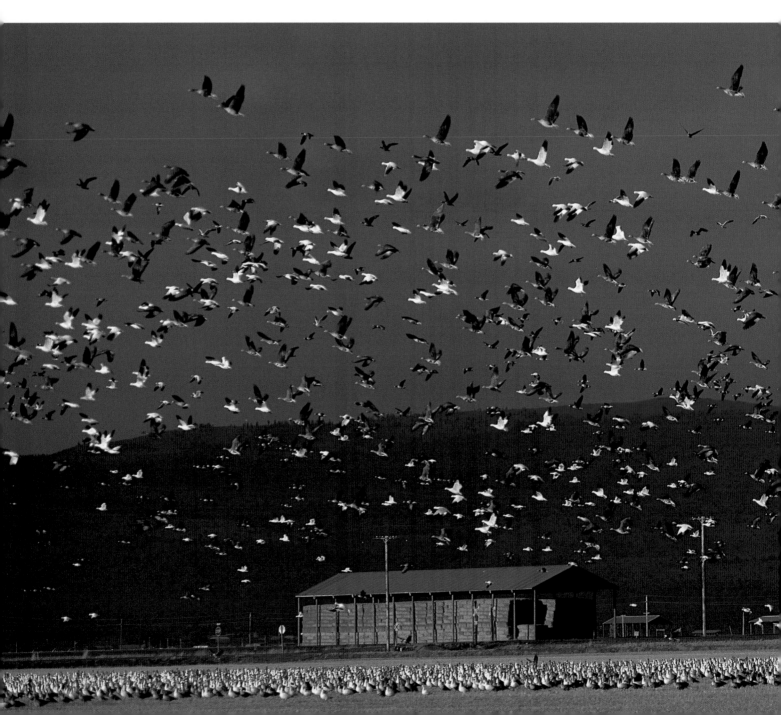

Growling badger, Montana.
© Doug Gaskill

Far more common and intended is the new feed and shelter left on the trail of the herd, the separate parts combining again to make it whole in a process of renewal. It is a learned experience, felt in the gut, like a sharply remembered encounter with the eyes of an innocent killer that slips silently away.

Farmland in the heart of the Pacific Flyway between Malin, Oregon and Tulelake, California. Sharing the harvest are snow geese, Canada geese, white-fronted geese and white pelicans. © Larry Turner

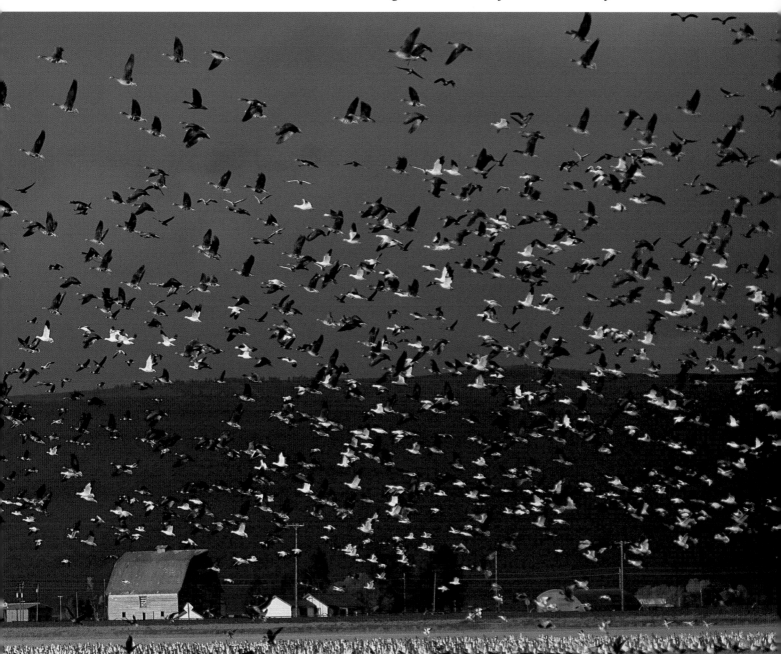

Pronghorns like to share ranch country. Where cattle graze the dry grasses, their waste and hoof action stimulates new growth for the antelope. Humboldt County, Nevada. © *Carolyn Fox*

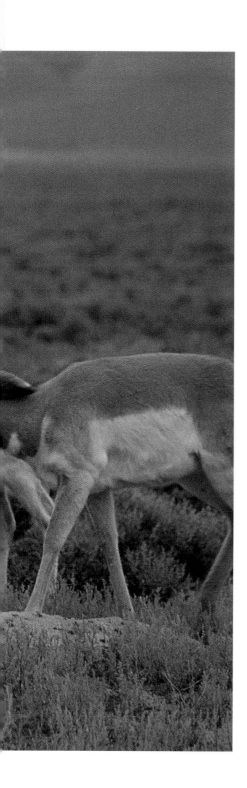

These three wild
raccoons share
coastal farmland in
California's
Mendocino County
with horses, cattle
and sheep.
© Larry Turner

This yellow-bellied marmot
stands on its hind legs to
get a better view, Sawtooth
Mountains, Idaho.
© Cynthia A. Delaney

A grizzly bear plays in an aspen forest near Driggs, Idaho.
© Cynthia A. Delaney

Collared lizard, Grimes Point, Churchill County, Nevada.
© Carolyn Fox

Mountain lions, also known as cougar, panther, painter, catamount, puma and wildcat, range throughout the Americas.
© Thomas Kitchin, Tom Stack & Associates

Coyote in henhouse, just taking one at a time.
© Thomas Kitchin,
Tom Stack & Associates

Desert Bighorn. Even these shy critters share the waters that ranchers provide.
© Thomas Kitchin,
Tom Stack & Associates

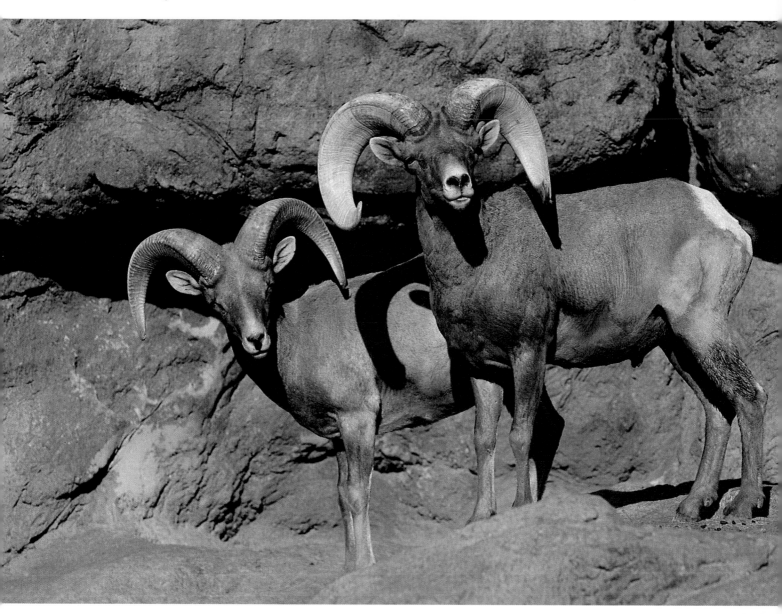

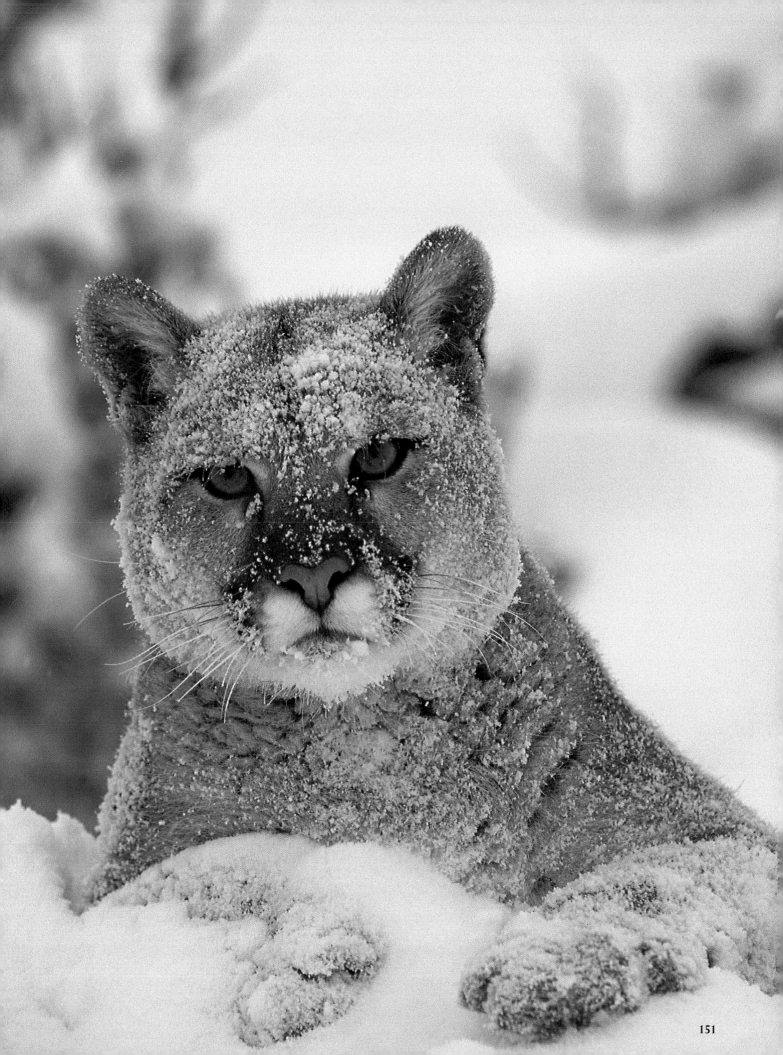

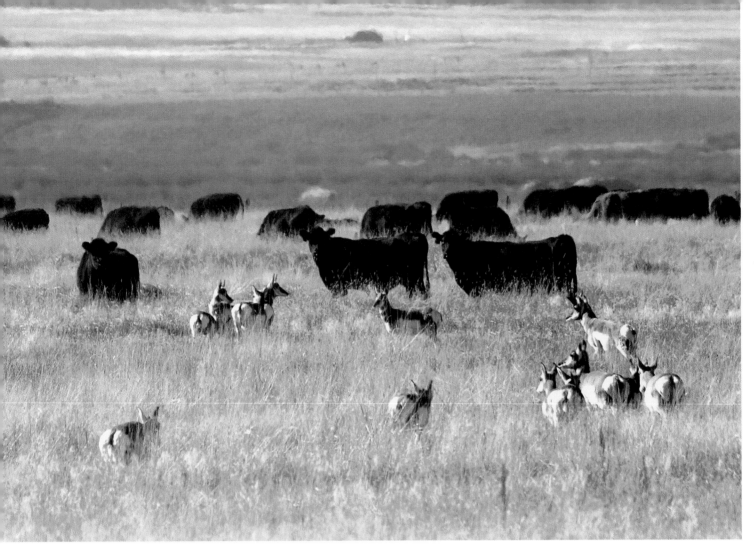

Pronghorns graze among livestock at the Huntley Ranch in Wisdom, Montana.
© *Cynthia Baldauf*

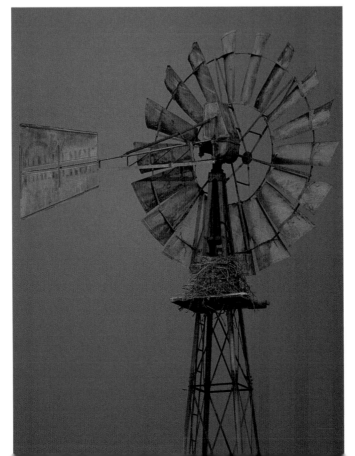

Ravens nest on a rancher's windmill in Hernandez County, New Mexico.
© *Larry Angier*

*White pelicans feed and travel on the irrigation
system built by the Bureau of Reclamation in the
early 1900s. This system of canals irrigates farms in
Klamath Basin on the California / Oregon border.*
© *Larry Turner*

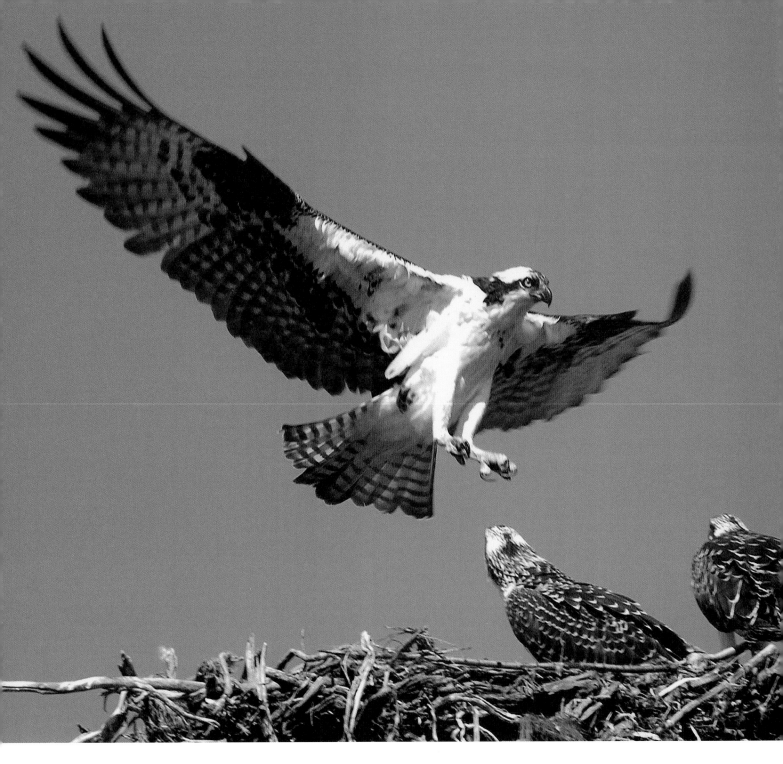

The young osprey are just hours from their first flight. To encourage flight, parents eat fish on nearby power poles. The young birds eventually brave it for their first hunting trip to the Big Hole River in southwest Montana. © Cynthia Baldauf

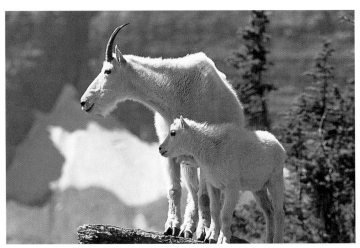

Mountain goats, mother and kid, peer across a meadow after emerging from the woods of Montana's high country. © Cynthia A. Delaney

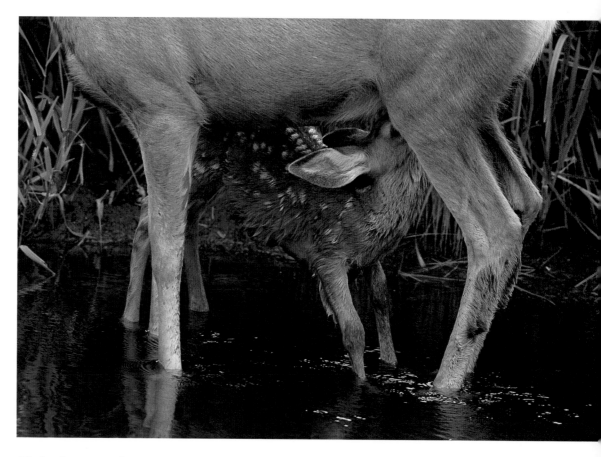

Mule deer and fawn stop for lunch in a creek drainage, southeastern Oregon.
© Cynthia A. Delaney

Gray wolf mother
runs with her pups
in Montana.
© Joe McDonald,
Tom Stack &
Associates

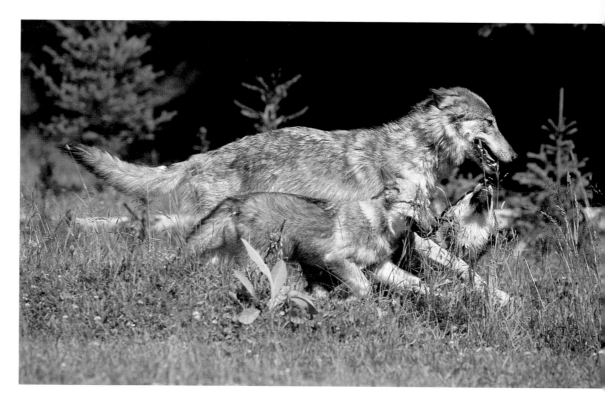

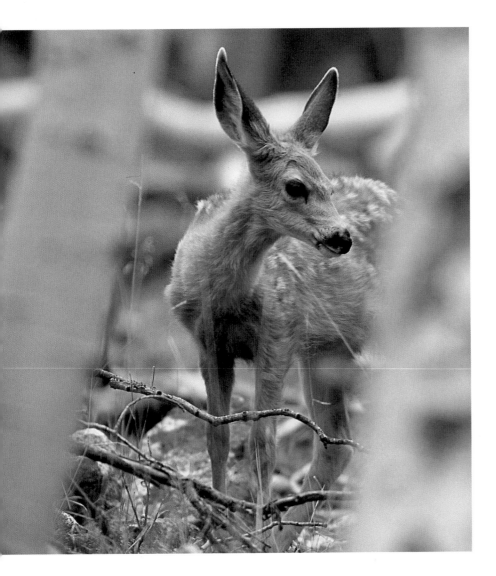

Mule deer fawn camouflaged in aspen grove on Success Loop in mountains near Ely, Nevada.
© Cynthia A. Delaney

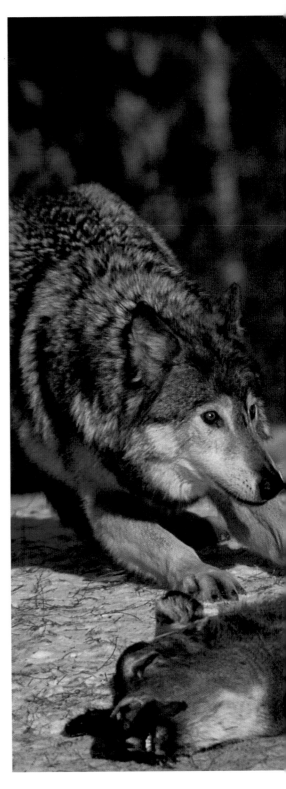

Predators and prey. Gray wolves feast on a white-tailed deer in the Northern Rockies.
© Thomas Kitchin, Tom Stack & Associates

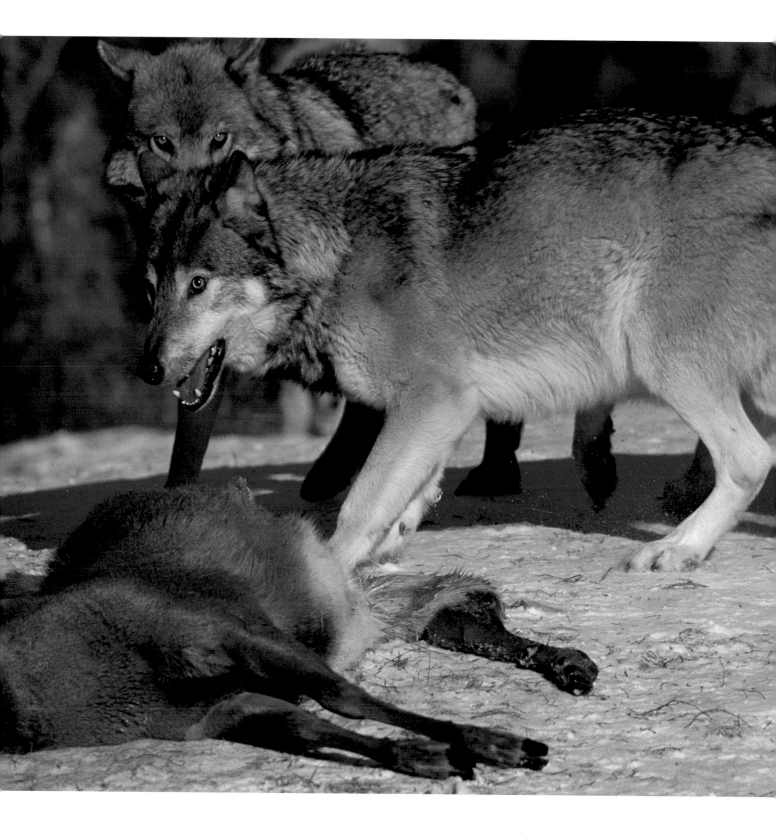

Hiding in the Sweet Wide Open

Somewhere in northwestern Nevada is a high, empty place that you will not find on any map. Its 300,000 acres of rolling sagebrush mountain-top, old uranium mine claims, and multiple-use rangeland are known to biologists, ranchers and hunters as Lone Willow. In early summer here, the mosaic of bunchgrass and wild-flowers is still green between low sagebrush. Snow fell deep in the high country last winter; good springs water the canyons, even in dry years.

The place is home to three thousand head of cattle in several Bureau of Land Management allotments, and a few domestic horses. Lone Willow anchors the eastern end of a strip of country that ends at Hart Mountain Refuge in southeast Oregon.

"The Lone Willow crescent," according to San Stiver, wildlife biologist and sage grouse guru for the Nevada Department of Wildlife, "is the most productive sage grouse habitat in the state of Nevada."

Sage grouse can range over miles of terrain, and although they tend to nest in the same neighborhood, they won't always. And let's admit this first. Nobody knows how many sage grouse there are, because nobody really knows how to count them.

Some people count the males at a lek site. A lek is not a place. It's an event where the male sage grouse get together, sometimes in the hundreds, and display during the breeding season. So it's more like a frat party than a frat house. (Think of inferring the number of male students at college by counting how many go to the frat parties.)

"We can't count all the leks, or even find them; there are just too many," says Stiver. Researchers may also capture grouse at night with spotlights, radio-collar them and track the birds to nesting sites, following and counting the chicks that survive.

One research biologist, working on a long-term project at Lone Willow, parts a low-growing sagebrush on a rocky, open slope where most of the vista is the clear Nevada sky. The brush hides half a dozen eggshells. Of course, everything eats sage grouse. Ravens eat eggs as well as young chicks; eagles, hawks, falcons, weasels, badgers, bobcats, coyotes, and cougars all eat sage grouse whenever they can. And then there are the human predators. But what helps the birds to survive?

Although conventional wisdom a decade ago said that sage grouse success would be improved by removing livestock, current studies seem to indicate otherwise. There are grazing animals on the nearby Sheldon Refuge, most notably significant numbers of wild horses. Lone Willow is multiple use, with cattle grazing in a rest-rotation plan and regular monitoring by BLM field personnel.

Range cattle have lived in peaceful coexistence with sage grouse for many years in Nevada. Raymond Gabica, now in his eighties, grew up on the Montana Mountains, which is part of Lone Willow. His family was in the sheep business.

"In the thirties and forties, there was a sheep camp on every ridge,

upwards of ten thousand sheep as well as at least three thousand head of cows," Gabica says. "There was a bunch of sage grouse at every spring. Of course, there were fewer predators."

People shot hawks and ravens; they trapped coyote and bobcat; and fire wasn't the issue then that it is now.

"We had a few fires then, lightning strikes," he continues. "Occasionally a sheepherder's campfire would get away from him, but it was nothing you couldn't take care of with a canteen of water and a good shovel. There weren't the big fires then that there are now."

The Pine Forest Range lies to the west of the Montana Mountains, between Lone Willow and the Sheldon Refuge. Louie Bidart, who grew up there raising sheep and cattle, has similar recollections of that period in history.

"There were thirteen bands of sheep on this mountain then, somewhere between twenty-five and thirty thousand. We had sheep until 1947. Sage hen nests were all over; inside sagebrush about thirty inches tall. It was common to flush four hundred birds off the meadow, especially the young ones. They ate the regrowth off the riparian areas after the sheep moved through, because it was tender."

It's not likely that the sheep industry will return to the western rangelands. Places where livestock have been entirely removed seem to have lost most of their sage grouse too, but the cattle that remain sup-

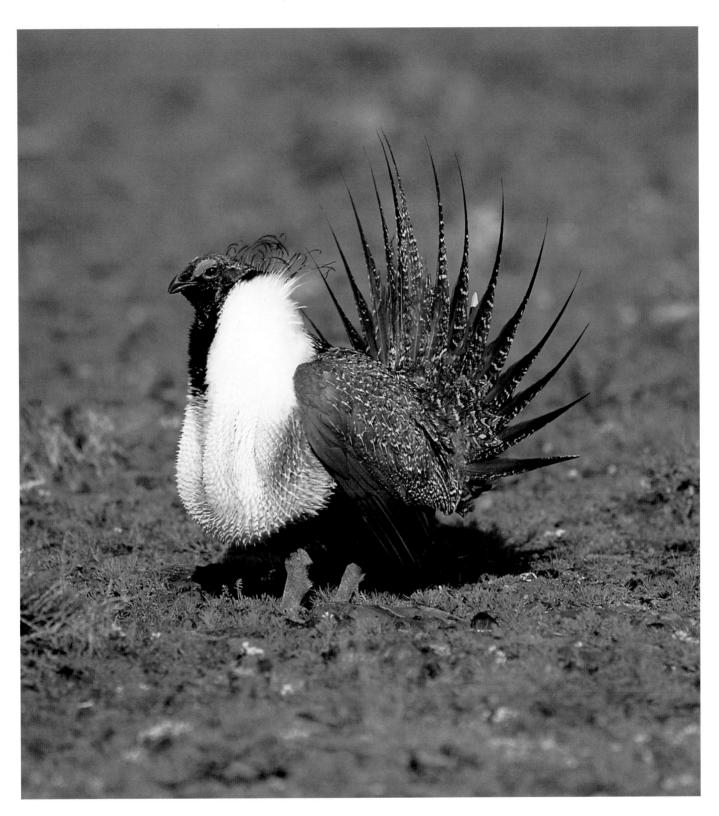

Male sage grouse struts, northern Nevada.
© *John Kallestad*

port a parallel population of sage grouse. They're just not easy to keep track of.

The late afternoon sun slants low through sage and wildflowers on top of the Montana Mountains. The biologist stops the truck. "There's a hen; no, two hens." As we watch, the hens cluck softly, and out of the bunchgrass, out of the dust of the two-rut jeep trail in front of us, rise five, six, now seven, three-inch-tall sage grouse chicks. They melt just as quickly as they appeared, into the lupines and the desert evening.

—*Carolyn Dufurrena*

A Vision of the West

As a photographer, I have always been attracted to the "decisive moment" photography of Henri Cartier-Bresson. And I have always loved the stark simplicity and honesty of the documentary work of Walker Evans, Dorothea Lange, and Arthur Rothstein.

A beautiful sunset lingers for a long time. It makes for a pretty picture, but those images don't appeal to me for long. I want to capture the fleeting moments of life that, in a split second, flicker to life and then are gone forever.

I walked into my first ranch cookhouse years ago, and immediately felt like I had walked into a classic Walker Evans photograph. Spare, simple, functional,

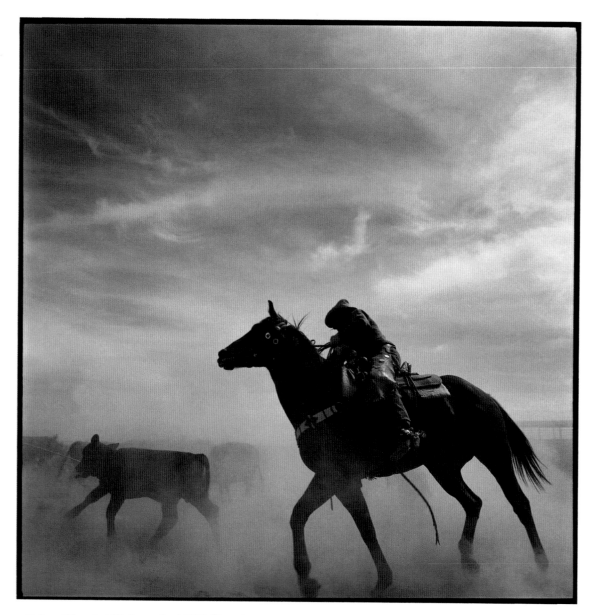

Fritz Merek, TS Ranch, 1995. © Adam Jahiel

honest, beautiful simplicity.

I wanted to find something meaningful to photograph, and this was it. Maybe it would keep me busy for a couple of years. Now, it is going on close to twenty.

During this time, I have watched children grow into adults and adults into grandparents. I have seen marriages, divorces, births, deaths, moves, job changes, successes, failures, triumphs and tragedies both large and small.

I worry that one day I will wake up and the urge to go back won't be there anymore. It has not happened yet.—*Adam Jahiel, Photographer <www.adamjahiel.com>*

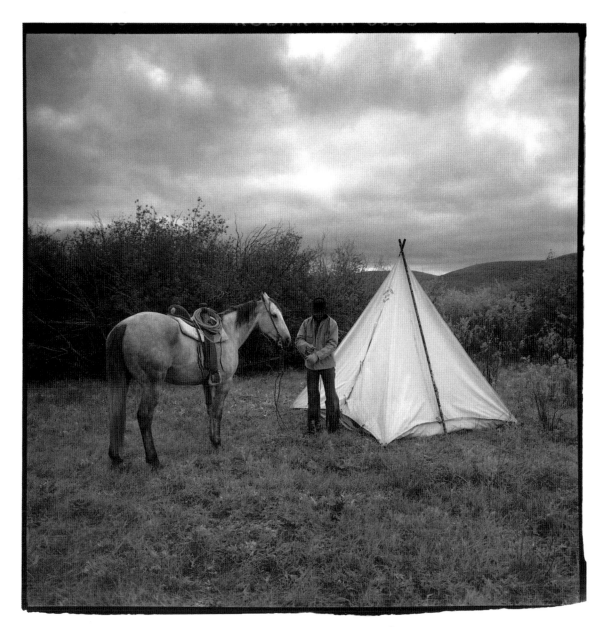

Morning, Cow Camp—Louie Hawkins, IL Ranch, 1991. © *Adam Jahiel*

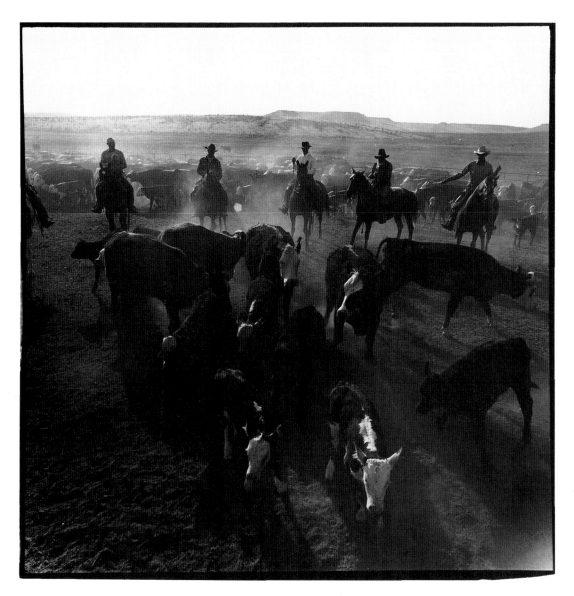

Roundup #2, YP Ranch, 1993. © *Adam Jahiel*

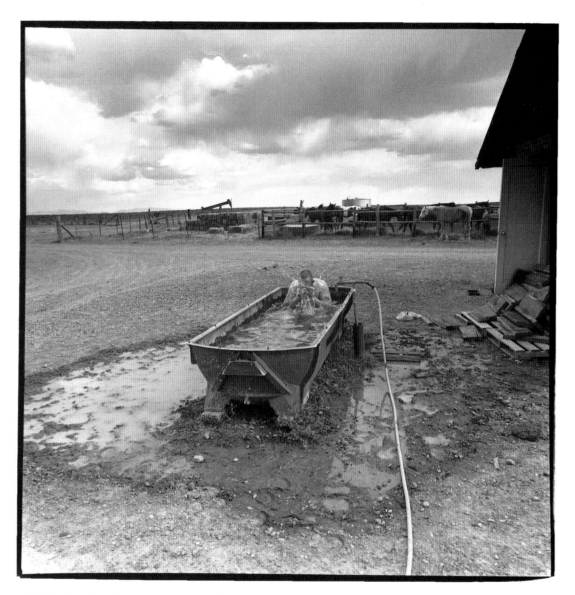

Billy's Bath, YP Ranch, 1993. © Adam Jahiel

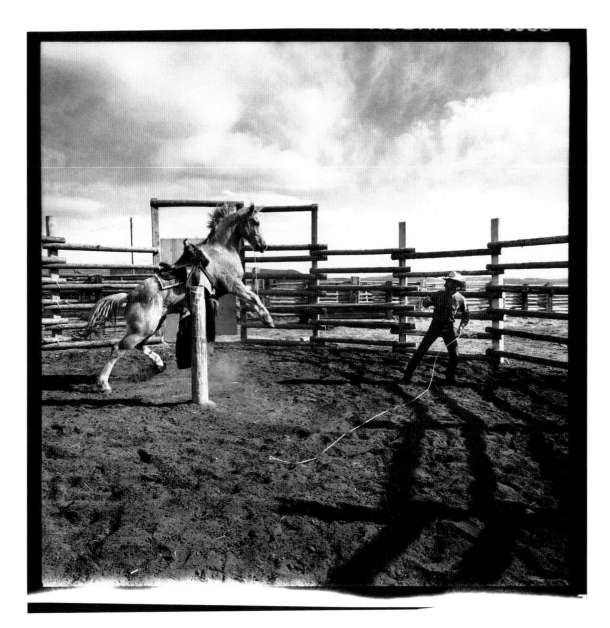

Rancho Grande, 1989—Bobby Lynn and Custer. © *Adam Jahiel*

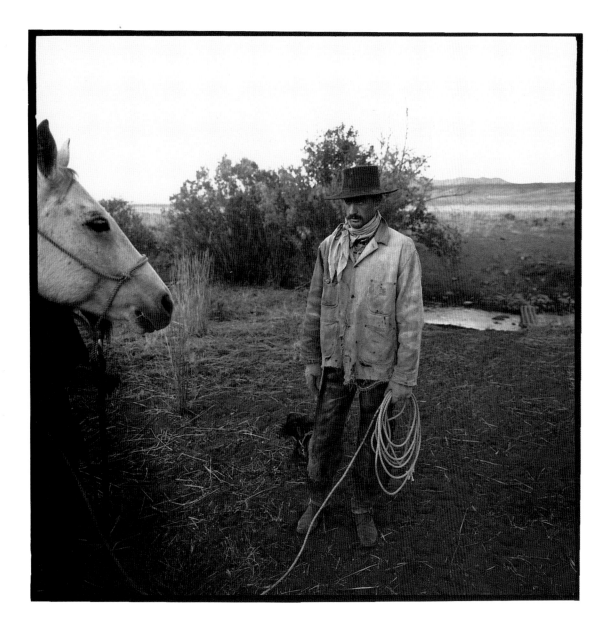

Louie's Stare—IL Ranch, 1990. © *Adam Jahiel*

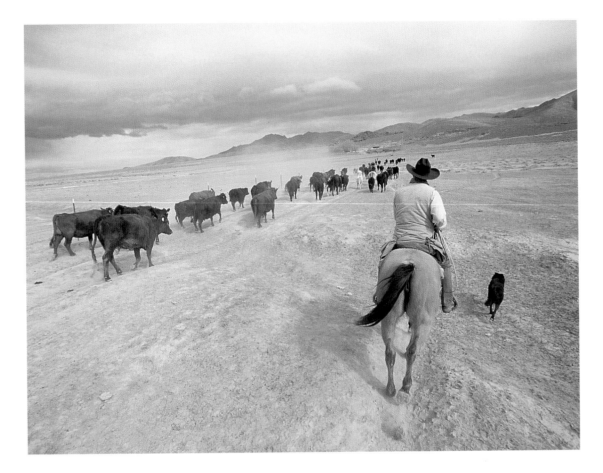

Roger Johnson, former watermaster for northern Nevada, trails cattle across Pumpernickel Valley's alluvial plain in March. Near Golconda, Nevada, it is bordered by the Sonoma and Buffalo mountain ranges. © *Larry Turner*